*Creating the*

# COUNTRYSIDE

## THE RURAL IDYLL PAST AND PRESENT

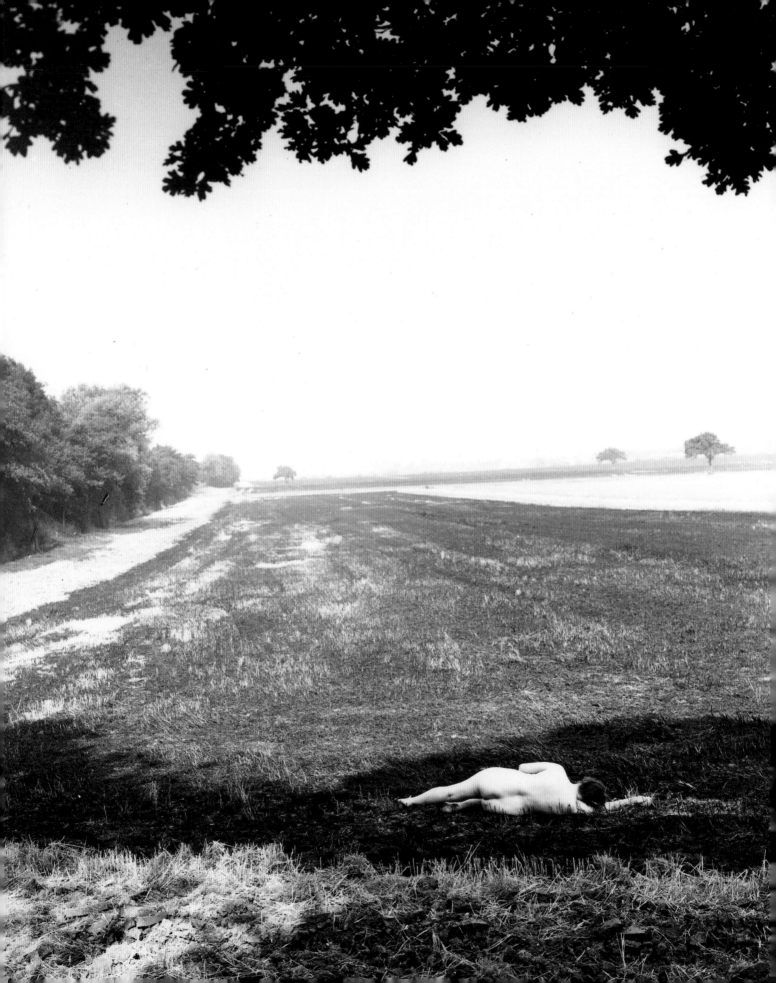

*Creating the*

# COUNTRYSIDE

## THE RURAL IDYLL PAST AND PRESENT

EDITED BY

**VERITY ELSON AND ROSEMARY SHIRLEY**

PAUL HOLBERTON PUBLISHING

Published to accompany the exhibition

*Creating the*
# COUNTRYSIDE
THOMAS GAINSBOROUGH TO TODAY

at Compton Verney
18 March – 18 June 2017

Copyright © 2017
Text copyright © the authors

ISBN 978 1 911300 10 6

British Library Catalogue in Publishing Data
A CIP record of this publication is available from the British Library

Produced by Paul Holberton publishing, London
89 Borough High St, London SE1 1NL
WWW.PAUL-HOLBERTON.NET

Designed and typeset by Laura Parker

Printed by Gomer Press Ltd, Llandysul, Wales

FRONT COVER
**PAUL REAS**
*Harvest of a Bygone Age, Home*
*Farm Museum, Hampshire*, 1993
Detail of fig. 2

BACK COVER
**JOHN CONSTABLE**
*The Cottage in a Cornfield*, c.1817–33
Detail of fig. 39

FRONTISPIECE
**JO SPENCE + TERRY DENNET**
*Remodelling Photohistory*
*(industrialization)*, 1982 (detail)
Vintage Gelatin Silver Print, 22.5 x 16 cm
© The Estate of Jo Spence, courtesy
of The Hyman Collection, London

# Contents

# Acknowledgements

The 'Capability' Brown landscape at Compton Verney provides the ideal setting for the exhibition *Creating the Countryside* and it is fitting that it was a contemporary installation in this same landscape by artist Hilary Jack that provided the genesis for the project. Hilary's perspective as an artist making work in and in response to the countryside formed the starting point for the exploration of the rural idyll almost four years ago, and I am grateful not only for the initial inspiration but also the conversations that have continued throughout its development.

The award of a Jonathan Ruffer Curatorial Grant from the Art Fund provided support for the exhibition at a crucial stage, facilitating the research time needed to bring together a rich array of works exploring the rural idyll past and present. I have been extremely fortunate to have as a partner in this endeavour Dr Rosemary Shirley, with the support of Manchester Metropolitan University. Her insight, expertise and enthusiasm have been invaluable and have made the realisation of both the exhibition and publication a hugely rewarding experience.

We are grateful to the museums, galleries, private collectors and artists who have generously lent works to the exhibition and for the conversations and collaborations which have helped to shape the project along the way. We would also like to thank Dr Oliver Cox and Tom Freshwater for their advice and enthusiasm, as well as colleagues, family and friends who have offered their support.

Finally, we would like to extend our thanks to The Paul Mellon Centre for Studies in British Art for the publication grant that made this book possible, to Paul Holberton and Laura Parker and to all of the contributors to this publication whose insights offer important new perspectives on the countryside and how it might be imagined.

VERITY ELSON, CURATOR
Compton Verney, March 2017

  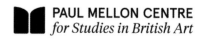

1
**SIR GEORGE CLAUSEN**
*Gleaners Coming Home*, 1904 (detail)
Oil on canvas, 92.7 x 122.6 cm
© Tate, London 2016

# Introduction

ROSEMARY SHIRLEY

The countryside is a powerful force in our national imagination. Many more of us live in towns and cities than in rural places and this physical disconnection has increased the cultural importance of the countryside. Our relationship to the land finds expression in what we buy, how we choose to spend our leisure time, and in conversations about global warming or plans for new power stations. Everyday decisions like choosing an organic chicken over a cheaper alternative or a fabric conditioner that claims to smell like a spring meadow reveal political, economic and imaginative connections to the idea of countryside. Our need for fresh air, to get out for a walk, to clear our heads, ties the countryside to ideas of physical and mental well-being. Large-scale protests against fracking in national parks or local petitions against housing developments in rural places point to our strong sense of how the countryside should look. But where have these ideas and associations come from and what makes them so pervasive in contemporary society? These are questions that this publication and the exhibition it accompanies aim to explore.

*Creating the Countryside* offers new ways of thinking about the rural through the innovative integration of art and everyday life. It includes key landscapes by artists such as Blake, Claude, Constable and Turner, works of modern British art, and contemporary works by artists who present new challenges and perspectives. These familiar and unfamiliar art works are entered into dialogue with an extensive range of visual cultures which populate everyday life now and in the past, for instance John Newbould's iconic wartime recruitment posters of 1942–44 and rural-themed video games, a set of exquisitely made corn dollies, and a range of national park-themed air fresheners. We assert that from High Art to propaganda, garden centres to air fresheners, and contemporary art to computer games, all these things form a constellation of powerful images and ideas that contribute to our understandings of the rural.

The exhibition and the essays in this volume move beyond the productive, but now familiar, critiquing of pastoral images of rural life or landscapes in order to replace them with a more 'realistic' portrayals of the countryside. Instead we ask: even though we know they are unrealistic, how do these images retain their charge? Why are they still so appealing? And how are they re-enacted, adapted and used today?

This book brings together new scholarship from a variety of perspectives and disciplines which reflects and refracts the multiple relationships between the countryside, art and everyday life. It begins with an essay by my co-curator Verity Elson and myself which discusses the works of art in the exhibition and the themes that emerge when these works are activated by each other. Contemporary assumptions about class, politics, privilege and representations of the rural are deconstructed by Nick Groom in his polemic essay '"Let's discuss over country supper soon": Rural Realities and Rustic Representations'. Jeremy Burchardt critiques the concept of the rural idyll, mapping its changed meaning over time and its significance today. The connections between art and farming are explored by Alice Carey, who investigates the political and economic journey from eighteenth-century artists employed to record the impressive

dimensions of genetically superior livestock to the contemporary taste for art galleries located in former farm buildings. In 'Smells like Rural Idyll' I explore how the concept of the countryside is used by major brands in the design and marketing of their products – inspired by a set of air fresheners made to emulate Britain's national parks. Nicola Bishop examines the enormously popular phenomenon of 'new' nature writing together with our hunger for images of the countryside on TV. In a visual essay, artist Georgina Barney documents her year living and working on fourteen different farms.

Interspersed throughout the publication are interviews with contemporary artists, who share their diverse approaches to the countryside as variously a home and as a site of production, consumption, heritage, destruction and creation – providing a detailed account of how rural places, communities and themes function in art practice today.

Collectively these essays and interviews offer a stimulating range of new perspectives on the role and importance of the countryside in contemporary culture.

2
**PAUL REAS**
*Harvest of a Bygone Age, Home Farm Museum, Hampshire*, 1993
Lightjet print, 50.8 x 61 cm
© The artist, courtesy of The Hyman Collection, London

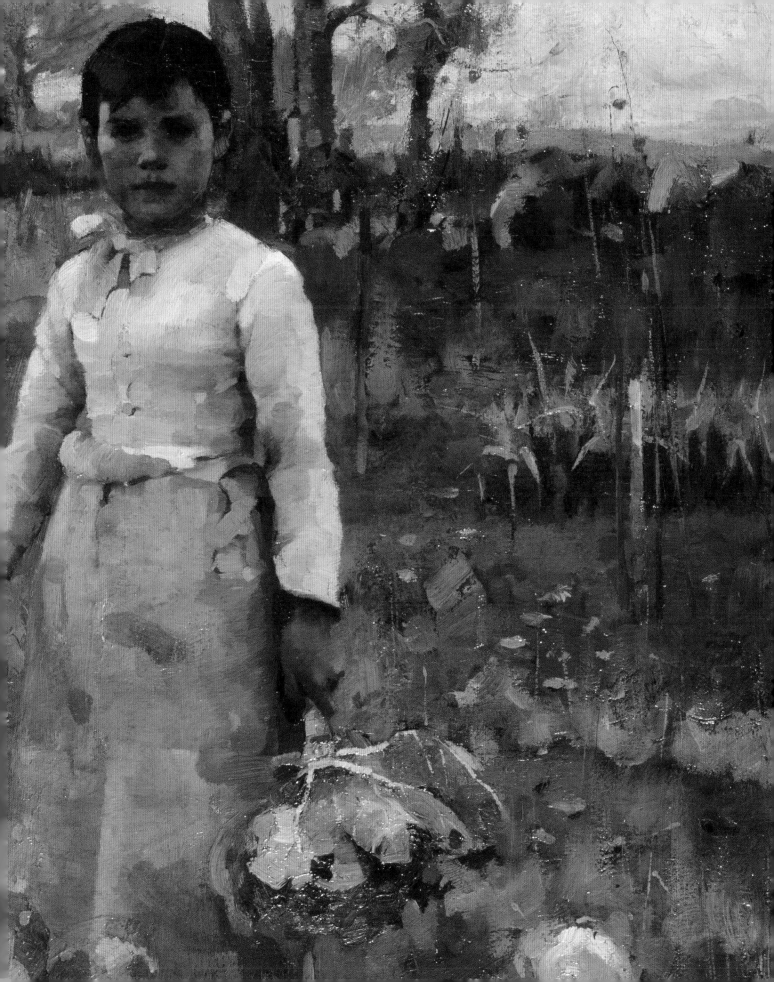

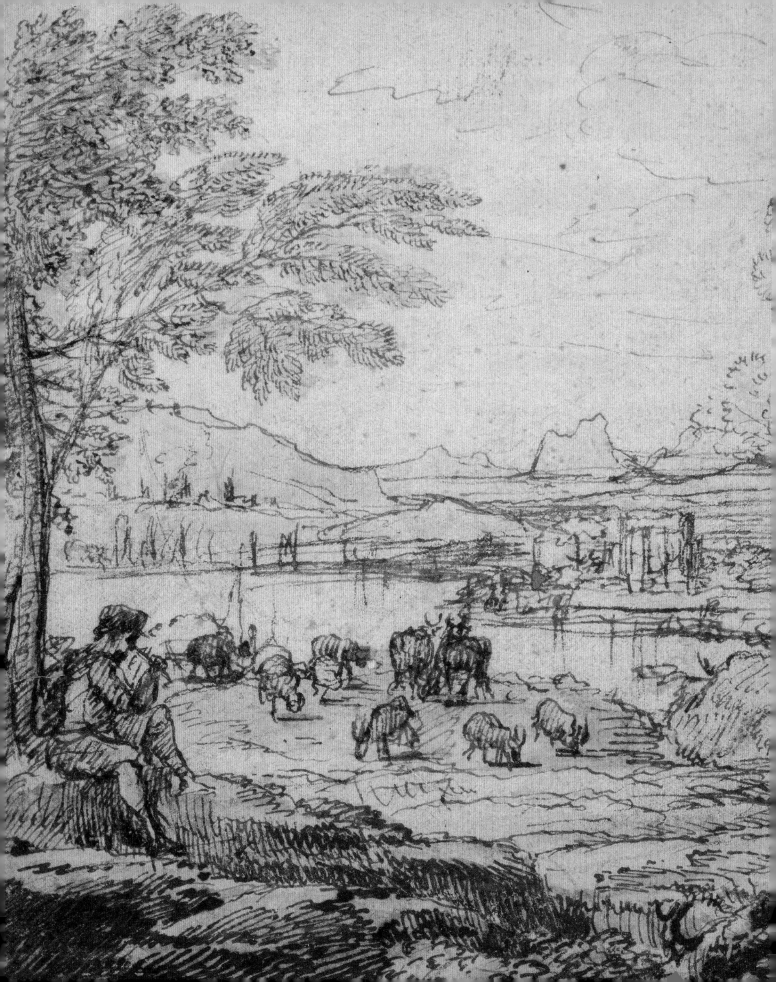

# Creating the Countryside

VERITY ELSON AND ROSEMARY SHIRLEY

## THE VIEW

The eighteenth-century landscape garden, fashioned into a series of 'pleasing prospects' by landscape architects including William Kent and 'Capability' Brown, signalled a new relationship with the land as a site of aesthetic appreciation. Artists such as Claude Lorrain (fig. 4) had provided a window on to Arcadia from the walls of the British country-house, in turn inspiring a new vision of the surrounding estate, as landscapes were modelled to replicate the artist's compositions on canvas.

The picturesque – a concept introduced by the writer and artist William Gilpin in 1768 – popularized the appreciation of the British landscape according to the aesthetics of painting. Taking in the view became an exercise in 'reading' the landscape, an experience framed by references to art and literature. Those inspired to follow Gilpin's example could also compose the view using a 'Claude' glass (fig. 5). This small convex mirror transformed an extensive vista into a neat landscape and the tinted glass made the reflection appear more like a painting. Ironically, the device requires the viewer to turn their back on the real landscape and gaze instead on its reflection.

The 'pleasing prospects' of the picturesque are today mediated through the camera lens, and, as Nicola Bishop explores in this volume, through advertising and television. The proliferation of this imagery subliminally shapes attitudes to the rural, just as the landscape gardens of 'Capability' Brown and his contemporaries have come to represent the quintessential image of the English countryside, appearing natural rather than designed.

In *Hollow Oak* (1995; fig. 6) by Mat Collishaw, this cultural framing of the view is made visible.

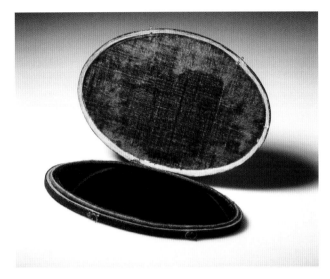

**5**
Claude glass, 1775–80
Blackened mirror glass, 21 x 14 cm
© Victoria and Albert Museum, London

**4**
**CLAUDE LORRAIN**
*Youth playing a pipe in a pastoral landscape*, c.1645 (detail)
Black chalk with pen and brown ink and pale wash on paper,
18.2 x 23.8 cm
© Ashmolean Museum, University of Oxford

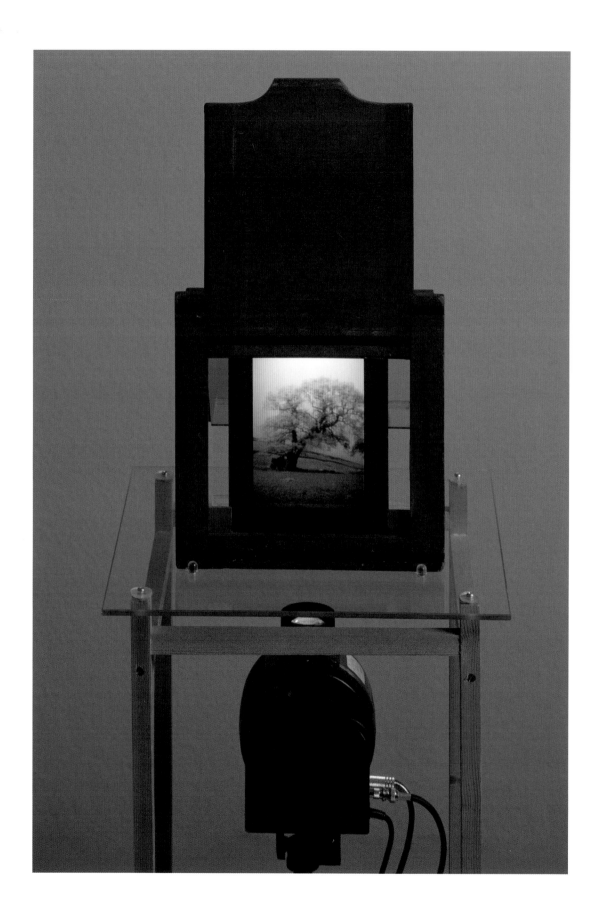

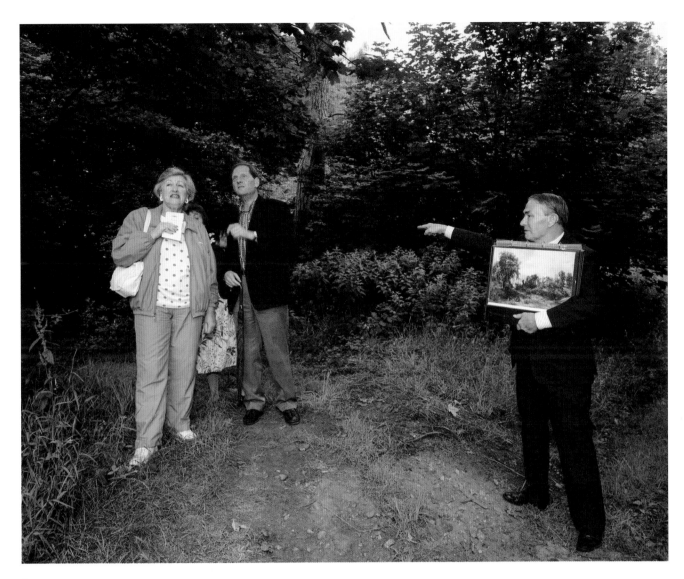

7
**PAUL REAS**
*Flogging a Dead Horse: Constable Country, Flatford Mill, Suffolk*, 1993
Lightjet print, 50.8 x 60.9 cm
© The artist, courtesy of The Hyman
Collection, London

6
**MAT COLLISHAW**
*Hollow Oak*, 1995
Video, projection, colour and sound,
wooden glass negative plate carrier,
mirror, wood and glass
© The artist, courtesy of Tate

A solitary oak tree – an icon of the English landscape – is contained within an original wooden case used to carry nineteenth-century photographic negatives. The projection on to etched glass evokes the nostalgic quality of an historic photograph but is slowly revealed as a moving image, animated by the sound of birdsong and rustling leaves. The mediation of the countryside is also explored in *Souvenir* by Hilary Jack (2012; see fig. 47, p. 75), as the picturesque imagery of the tourist postcard is filtered through a wooden 'eye'. The controlled view amplifies the sense of separation and observation that is central to the concept of landscape.[1] Meanwhile the view from the

kitchen window in Andy Sewell's series *Something like a Nest* (2014; see fig. 35, p. 48) takes us beyond the conventional framing of the countryside, as the romantic pastoral of the imagination is surrendered to the details of everyday life.

The search for the 'authentic' experience of the countryside and its manifestation in the contemporary tourism and heritage industries is explored in *Constable Country* by Paul Reas (1993; fig. 7). The tourists' gaze is directed by a guide, who, by holding aloft an image of Constable's landscape, confirms the correct site from which the artist's rural idyll will be revealed. The multi-layered framing of the countryside – as a landscape painting, as a tourist experience and finally in the work of Reas himself – offers a critique of the heritage industry by exploring the tension between imagination and experience in the search for the perfect view.

## THE PLEASURES OF THE COUNTRYSIDE

The pastoral genre is the idealized portrayal of the rural as a place of plenty, rest, innocence and beauty. In their essays Nick Groom and Jeremy Burchardt detail its roots in poems of classical antiquity. Figures included in these landscapes were usually popular rustic characters like peasants, cherubic children and shepherds against a background of leafy glades and attractively ruined buildings. Shepherds were a favourite subject, because their lifestyle could be easily romanticized – working outdoors in beautiful landscapes, primarily sitting and thinking, maybe singing or composing poetry, occasionally chasing pretty girls. This aestheticization of rural life and labour can be seen in the Toiles de Jouy pattern which originated in the eighteenth century but is still popular today for furnishing fabrics and wallpaper.

The fabric design *Pleasures of the Countryside* (c.1880; fig. 8) is an original piece of Toiles de Jouy, designed by Jean-Baptiste Huet, who is also notable for his many paintings of pastoral scenes. It was manufactured at the factory established in 1760 by Christopher-Philippe Oberkampf at Jouy-en-Josas – Toiles de Jouy literally means 'cloth from Jouy'. This location was favourably sited between Paris and Versailles, the main residences of the French court, who were the primary market for these textiles. The French royal family enjoyed such fantasy representations of the countryside: famously, Marie Antoinette had a rural retreat – Hameau de la Reine – built for her in the grounds of the Palace of Versailles, including a farm, diary, mill and barn that also served as a ballroom. In her specially constructed rural hamlet she dressed as a shepherdess and lived out a rural fantasy of her own.

Perhaps Marie Antoinette was in the minds of the designers at Horrockses, a Lancashire cotton manufacturer that diversified into ready-to-wear gowns after the Second World War. The firm became famous for designs influenced by the 'New Look' style pioneered by Christian Dior in 1947, with its full skirts and extravagant use of material providing a much needed post-war fantasy of plenty. As women returned to the home after taking on jobs vacated by men during wartime or serving in the forces themselves, the New Look suggested both glamour and domesticity.[2] Around 1947 Horrockses produced a dress in a pink Toiles de Jouy. It features romantic encounters between shepherdesses and swains framed by a rustic landscape and garlands of flowers. Both the distinctive silhouette of the dress and the fabric design speak of a fantasy of the kind of decadent elegance that was in short supply in the years directly after the war.

These two locations, Northern France and Lancashire, also form the twin axis points for Ingrid

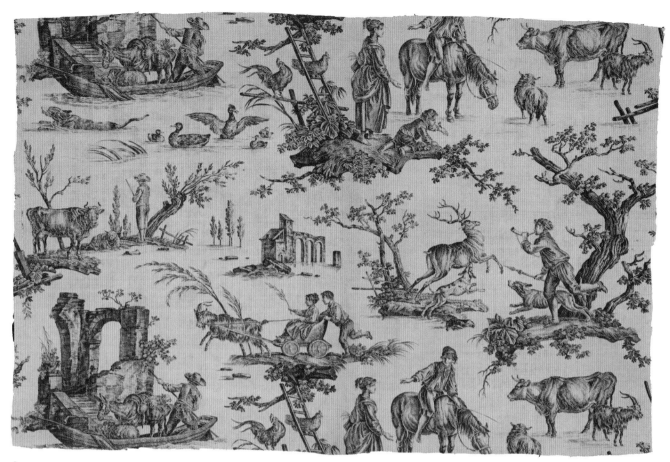

**8**
**OBERKAMPF** (manufacturer)
**JEAN-BAPTISTE HUET** (designer)
*The Pleasures of the Countryside,* c.1800
Copperplate-printed cotton, 62.2 x 94.6 cm
© Victoria and Albert Museum, London

Pollard's re-working of the Toiles de Jouy design for her piece *There Was Much Interruption* (2015; fig. 58, p. 99). In her interview for this book, she talks about the inspiration for this piece that references modern rural labour as well as images referring to the histories of world trade and exploitation of people and natural resources.

## THE PEASANTS

Thomas Gainsborough's portrait of his daughter in peasant costume, *Margaret Gainsborough Gleaning* (late 1750s; fig. 9), and George Clausen's *Gleaners Coming Home* (1904; see fig. 2, p. 7) reflect the enduring romantic appeal of rural life. Just as the shepherd of the classical pastoral tradition had offered a glimpse into a timeless world, so the image of the rural labourer became imbued with the ideals of the harmony of a pre-industrial Golden Age. The period of over 150 years that separates these two works witnessed the transformation of Britain from a rural to an urban nation, and it is in images of the countryside that many of the anxieties surrounding the associated social changes are played out.

William Collins' *Rustic Civility* (1833; fig. 10) implicates the viewer directly in the harmonious vision of the countryside as we share the perspective of the figure on horseback, present only in the form

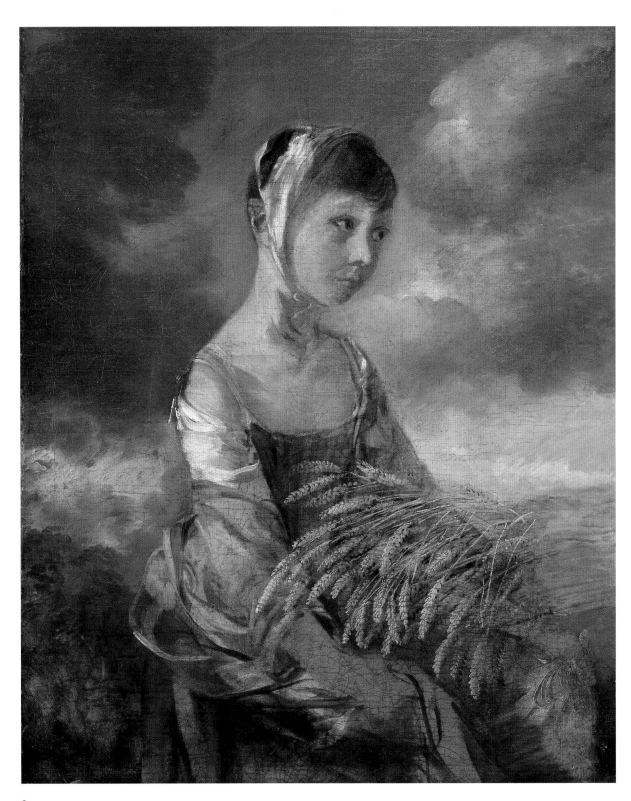

**9**
**THOMAS GAINSBOROUGH**
*Margaret Gainsborough Gleaning*,
late 1750s
Oil on canvas, 73 x 63 cm
© Ashmolean Museum,
University of Oxford

**10**
**WILLIAM COLLINS**
*Rustic Civility*, 1833
Oil on panel, 45.6 x 61 cm
© Victoria and Albert Museum,
London

of his shadow. The 'rustic civility' exhibited by the children – one of whom tugs his forelock in deference – reflects one of the primary appeals of rural imagery during this period, the idea of a stable social hierarchy. It was a vision that catered to the tastes of both aristocratic patrons and wealthy industrialists, fuelling demand for genre works. The commanding figure of *The Laird* by John Pettie (1878; fig. 11) and the clearly defined relationship between landowner and labourer in John Robertson Reid's *Toil and Pleasure*

(1879; fig. 13) embodied a way of life and a set of values that were prized, and mythologized, as an antidote to the changing social relationships experienced in both town and countryside.

John Constable's oil sketch *Spring: East Bergholt Common* (c.1814; fig. 12) conveys a sense of the timeless quality of the agricultural landscape, yet it also bears witness to an important period of change, recording the ploughing of recently enclosed common land. The period of rural unrest that accompanied the

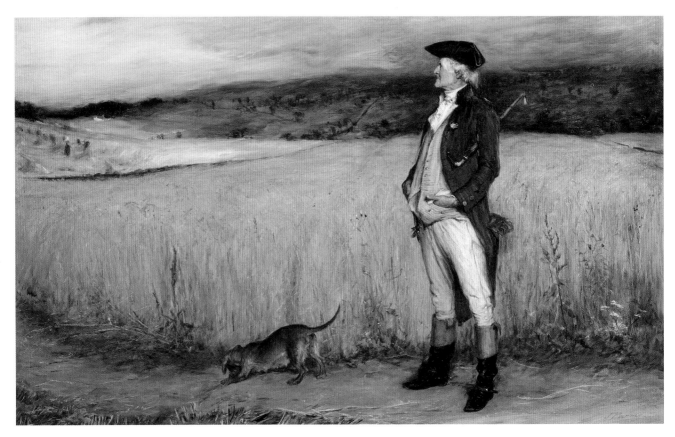

**11**
**JOHN PETTIE**
*The Laird*, 1878
Oil on canvas, 56 x 89 cm
© Dundee City Council (Dundee's
Art Galleries and Museums)

enclosures meant that comforting images of an unchanging world and a virtuous, contented peasantry were ever more appealing.

The influence of 'truth to nature' and *plein-air* techniques in Continental painting prompted new engagements with agricultural landscapes in Britain in the latter half of the nineteenth century. A group of painters known as the Glasgow Boys, exposed to the work of artists including Jean-François Millet (fig. 14) and Jules Bastien-Lepage, were drawn to Scotland's rural fringes. Two of the most celebrated works of the Glasgow School, Edward Arthur Walton's *Berwickshire Field-workers* (1884; fig. 15) and James Guthrie's *A Hind's Daughter* (1883; fig. 16), were painted in and around the Berwickshire village of Cockburnspath, home to a

community of landscape and figure painters. Walton's striking image of field-workers – their faces obscured by distinctive bonnets known as 'uglies' – signalled a new approach to the representation of rural labour, but principally as a vehicle for radical technique and capturing the effects of heat and light. *A Hind's Daughter*, painted the previous year, also depicts female labour, this time the daughter of a hind (a farm labourer, who, customarily in this region, would have been obliged to provide a female worker as part of his contract). The girl gazes out from the winter landscape, knife in hand, as if we have just interrupted her at her work. In making eye contact we are asked to view her as an individual. Guthrie's treatment of the subject disrupts the conventions of

**12**
**JOHN CONSTABLE**
*Spring: East Bergholt Common*, c.1814
Oil on panel, 19 x 36.2 cm
© Victoria and Albert Museum,
London

**13**
**JOHN ROBERTSON REID**
*Toil and Pleasure*, 1879
Oil on canvas, 99.1 x 182.2 cm
© Tate, London 2016

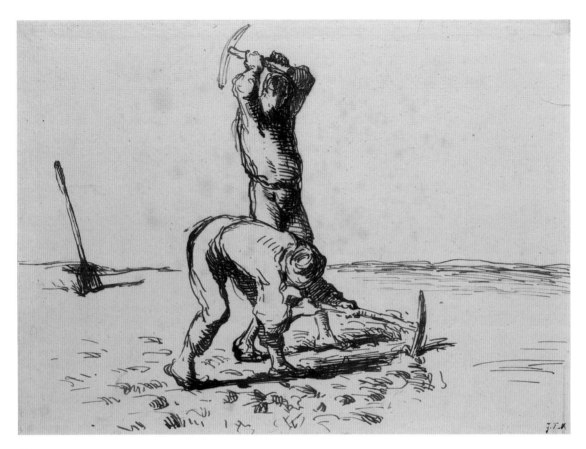

**14**
**JEAN-FRANÇOIS MILLET**
*Two peasants digging with*
*pickaxes*, c.1844–46
Pen and brown ink on paper, 22.8 x 30.6 cm
© Ashmolean Museum, University of Oxford

depicting children as playful innocents and of the
nostalgia for childhood that is inextricably linked
with nature and the projection of rural harmony.[3]

George Clausen also pushed towards social realism
during this period, but unromanticized scenes were
often rejected by the selectors of the Royal Academy
annual exhibitions. In an era when the demands of
the market had taken precedence, the radicalism
that characterized many of these artists' European
counterparts was rarely allowed to surface.

The spirit of the peasant paintings of artists such
as Van Gogh and Millet re-emerges in the twentieth
century in the work of Josef Herman. The weight of
labour in the hunched figures of Herman's *Potato*
*Diggers* (1940–54; fig. 17) echoes the back-breaking
work depicted in Millet's drawing *Two peasants*
*digging with pickaxes* (c.1844–46; fig. 14).

In her interview for this book, Sigrid Holmwood
talks about how her work expands the understanding
of the term 'peasant painting' to include 'peasants that
paint'. Holmwood uses costume and performance in
her practice, re-enacting and re-imagining the figure
of the peasant. This work becomes a pleasing critique
of the fantasies of rural labour seen in the painting
of Margaret Gainsborough dressed as a gleaner. The
practice of gleaning – gathering left-over produce once
the main crop has been harvested – has also been
not so much re-enacted but re-invigorated by Kathrin

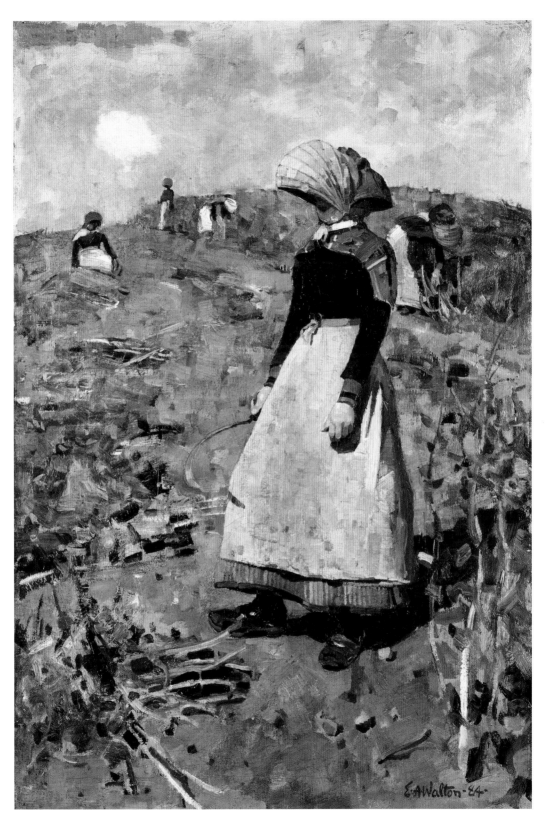

**15**
**EDWARD ARTHUR WALTON**
*Berwickshire Field-workers*, 1884
Oil on canvas, 91.4 x 60.9 cm
© Tate, London 2016

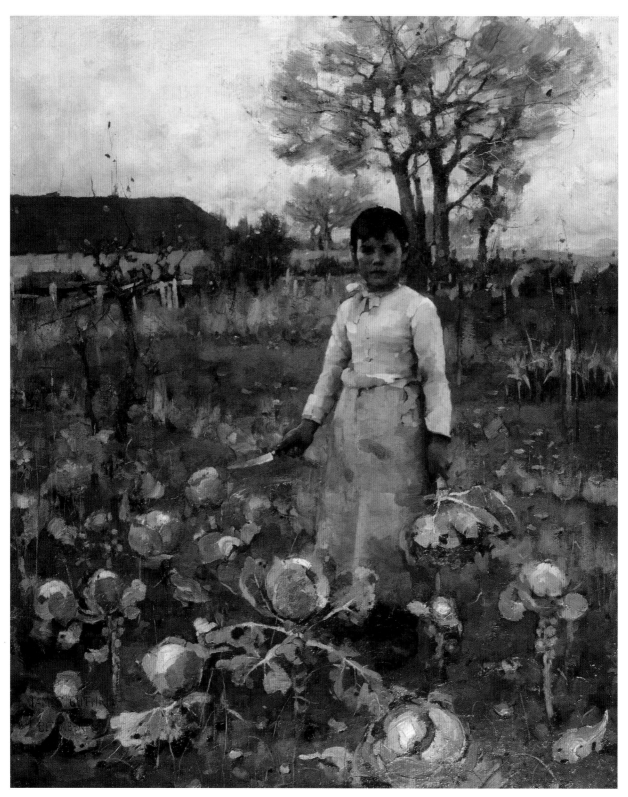

**16**
**SIR JAMES GUTHRIE**
*A Hind's Daughter*, 1883
Oil on canvas, 91.5 x 76.2 cm
© National Galleries of Scotland

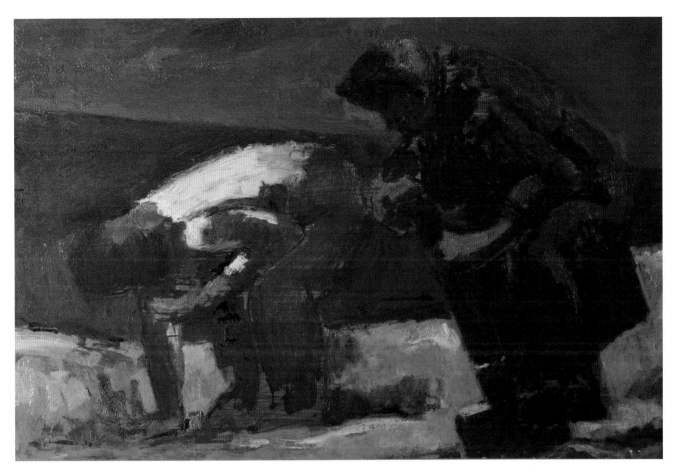

Böhm from the artist group Myvillages in their project Company: Movements, Deals and Drinks. Böhm worked with residents from the London Borough of Barking and Dagenham to create a community drinks company using ingredients from local parks and the nearby countryside. Fruit farms in Kent and Essex contracted to grow blackcurrants for Ribena allowed them to glean their leftovers for an extremely tasty Blackcurrant Soda (fig. 18).

## THE DARK PASTORAL

An important work in the pastoral genre is Nicolas Poussin's *Et in Arcadia Ego* or *The Arcadian Shepherds* (1637–38). The painting depicts three shepherds encountering a tomb. The title is usually translated as 'Even in Arcadia there I am' and widely interpreted to mean that even in Arcadia death cannot be escaped. As detailed above, the pastoral is most often associated with the pleasures of the countryside, but in this painting death and the pastoral walk hand in hand. It is not just in high art that we see this combination: as Nicola Bishop details in her essay, these elements coalesce in the cosy nostalgia TV versions of the pastoral represented by shows like

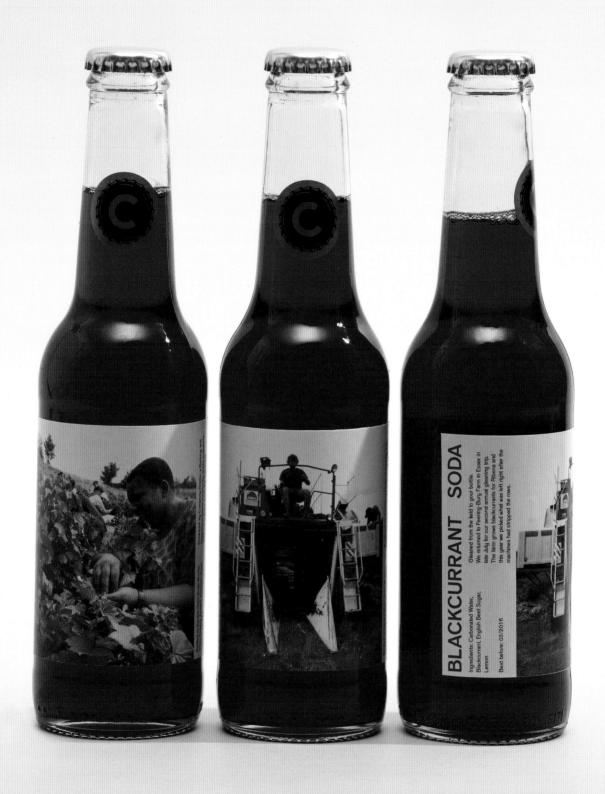

BLACKCURRANT SODA

Gleaned from the field to your bottle.
We returned to Feering-Bury Farm in Essex in
late July for our second annual gleaning trip.
The farm grows blackcurrants for Ribena and
this year we picked what was left right after the
machines had stripped the rows.

Ingredients: Carbonated Water,
Blackcurrant, English Beet Sugar,
Lemon

Best before: 03/2016

*Midsomer Murders* and adaptations of Agatha Christie's
Miss Marple stories. We have become habituated to
the idea that a walk through the woods might reveal
a body and that behind the cottage door may lie a
grisly murder. This relationship is made evident in
Anna Fox's series *Country Girls*, made between 1996
and 2001 in collaboration with Alison Goldfrapp
(see fig. 23, p. 31, and fig. 40, p. 61). In her interview
for this publication Anna Fox comments on the way
these images play with the relationship between
glamour and horror, speaking of the claustrophobia
and limitation the two women felt growing up in the
countryside in the 1970s and 1980s (see pp. 61–63).

*Et in Arcadia Ego* is the title of the first book in
Evelyn Waugh's *Brideshead Revisited* (1945), and refers
to the idea that the idyll of youth and privilege,
depicted so powerfully in the book, will be shattered
in many ways, but perhaps most tragically through
the Second World War. There are many surprising
connections between the pastoral and modern
warfare. In Ian Hamilton Finlay's stone carving
(1976; fig. 20), which borrows Poussin's title and
elements from his painting, the tomb has become
a tank made of bricks, and the light stone seems to
reference war memorials like the cenotaph or the
fields of white crosses which populated military
graveyards. The work stands as a *memento mori* –
a reminder that through the actions of man the
peaceful idyll has been lost, both metaphorically
but also in very real ways, through warfare and
exploitation of natural resources. Peter Kennard's
photo-montage *Haywain with Cruise Missiles* (1980;
fig. 21), also subverts an iconic landscape painting.
Kennard's work makes visible the fact that idyllic
rural locations are often host to disturbing Ministry
of Defence activities.

In Robert Baden-Powell's book *My Adventures as a
Spy* (1915), the pastoral becomes a weapon of war in

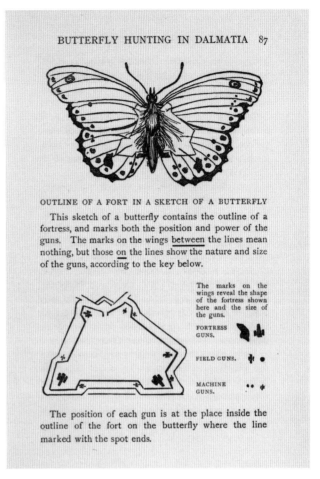

itself. The author uses the term 'weaponization of the
pastoral' to describe how he used drawings of flora
and fauna to hide secret information. He shows how
the patterns on a butterflies' wings conceal a map of
a military installation and the location of field guns
(fig. 19). The pastoral was also utilized to galvanize
patriotic feeling during the Second World War. Frank
Newbould, who had found success as a designer of
travel posters, put his talents to use producing a series
of propaganda images depicting the British Isles as
a nation of rolling hills and charming villages. His
image of the South Downs uses the classic pastoral

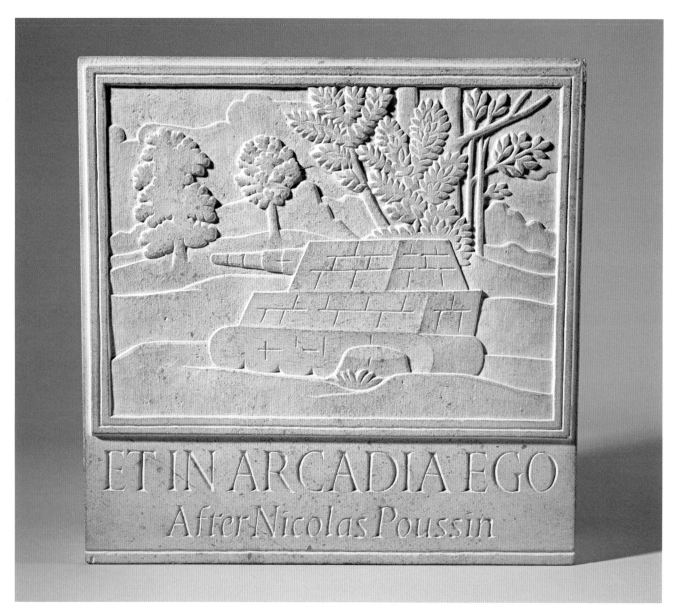

20
**IAN HAMILTON FINLAY**
*Et in Arcadia Ego*, 1976
Stone, 28.1 x 28 cm
© The Estate of Ian Hamilton Finlay,
courtesy of National Galleries of Scotland

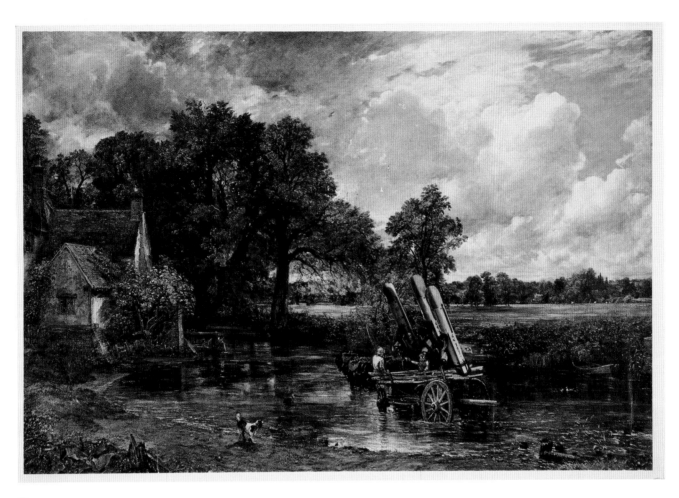

21
**PETER KENNARD**
*Haywain with Cruise Missiles*, 1980
Chromolithograph on paper and
photographs on paper, 26 x 37.5 cm
© The artist, courtesy of Tate

motif of the shepherd, overlaid with the slogan
'Your Britain – fight for it now' (1942; see fig. 50, p. 81).

Working as a war artist Evelyn Dunbar documented
the work of the Women's Land Army. Her painting,
*A 1944 Pastoral: Land Girls Pruning at East Malling*,
(fig. 22), refers to the pastoral tradition in the title;
however, this is far from an idealized depiction of
rural labour. It is a cold landscape, with a grey sky
and a long avenue of bare-branched apple trees, which
all have to be pruned. The women, bundled in coats
and headscarfs, look frozen. The image is bordered
by depictions of the women's hands holding the

tools of their trade, in various gestures involved in
the act of pruning. This addition may be related to
Dunbar's work as an illustrator of publications like
*A Book of Farmcraft* (1942), which features step by
step instructional drawings for various agricultural
tasks. However, the inclusion of a large serrated knife,
a handsaw and pruning shears add a disquieting
element of potential violence – especially when
viewed next to Anna Fox's *Country Girls*.

This unsettling edge to the pastoral can also be
seen in John Piper's *Derelict Cottage* (1940; fig. 24).
This dark painting depicts an abandoned cottage: its

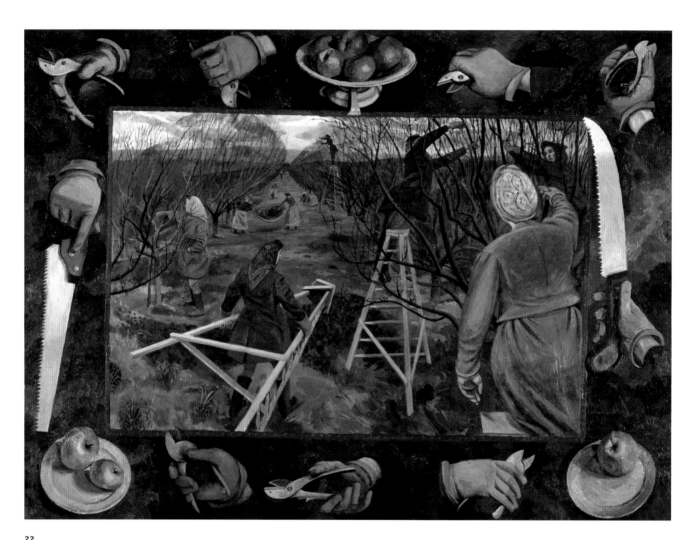

**22**
**EVELYN MARY DUNBAR**
*A 1944 Pastoral: Land Girls*
*Pruning at East Malling*, 1944
Oil on canvas, 91.3 x 121.8 cm
© The Estate of Evelyn Mary Dunbar,
courtesy of Manchester Art Gallery

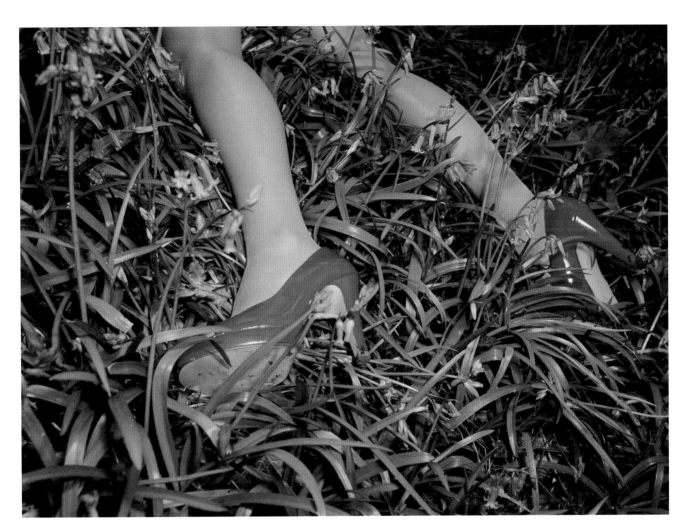

**23**
**ANNA FOX + ALISON GOLDFRAPP**
*Untitled*, from *Country Girls*, 1999
C-Type colour print, 102 x 142 cm
© The artists, courtesy of The Hyman
Collection, London

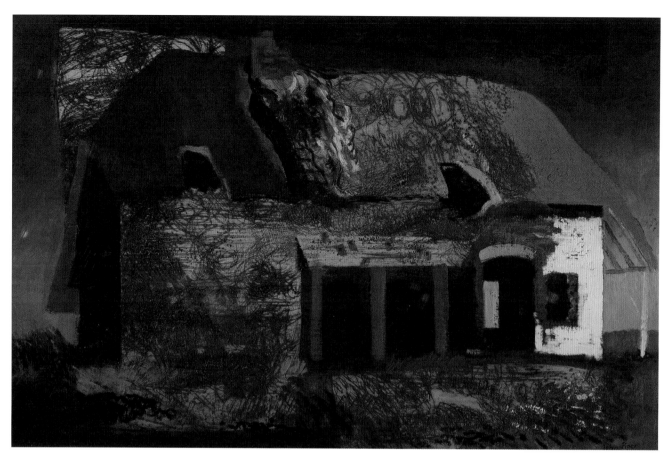

**24**
**JOHN PIPER**
*Derelict Cottage, Deane, Hampshire*, 1940
Oil on canvas and panel, 51 x 76 cm
Leicester Museum & Art Gallery,
Leicestershire, UK / Bridgeman Images
© The Piper Estate / DACS 2016

doors and windows are black holes, its thatch is in disarray. Ruins are often a feature of pastoral scenes, but when we note the wartime date of this painting and perhaps view it in conjunction with Hilary Jack's sculpture about the impending environmental disaster promised by the Anthropocene (see fig. 46, p. 74), Piper's work takes on a different significance, becoming perhaps a document of an imagined or real post-apocalyptic future.

## THE SLEEPY VILLAGE

In John Wyndam's book *The Midwich Cuckoos* (1957), the whole village of Midwich suddenly falls asleep during the day. They awake several hours later, and seemingly little harm has been done, but as the weeks pass by it becomes apparent that all the female villagers are pregnant, and all conceived during those lost hours. It soon becomes clear that the babies are not human and they reveal themselves to be part of an alien invasion. That a typical rural English village with shop and post office, village green and pub, should be the location for such an alien experiment points to its perceived remoteness, chosen because these alien children would be able to grow up unchallenged and

isolated from the outside world. It is discovered that
the aliens have also infiltrated communities in the
Arctic circle, a remote village in south-west Australia
and a tribe on the borders of Russia and Mongolia.
That a village in the south of England is thought to
have the same qualities of isolation as these other
locations reveals metropolitan attitudes towards
rural areas of the country.

The English village often becomes a screen
which reflects the anxieties of the nation. In the
wartime film *Went the Day Well?* (1942), a village
plays unwitting host to invading German soldiers.
Posing as English troops the enemy is barracked
within the homes of the villagers, only to turn upon
them. By the 1950s these wartime anxieties were
focused on the USSR, the Cold War, and the idea of
spies living amongst us. This, combined with the
space race and the increased interest in life on other
planets, must have informed Wyndham's Midwich.
But his pastoral sci-fi also draws on anxieties about
the English village itself. Postwar developments in
technology and infrastructure, a decrease in farm
labour and shifts in population were changing the
face of rural communities. For Wyndham the village
is simultaneously under threat and sinister. Its
remoteness is to be preserved but also feared.

Wyndham's legacy can be detected in the popular
and critically acclaimed contemporary video game
*Everybody's Gone to the Rapture* (2015; figs. 25 and 26).
Players explore a detailed simulation of a Shropshire
village called Yaughton. The place is deserted: clearly
some event, outbreak or alien presence has emptied
the place of its inhabitants, leaving players to gather
clues from radio broadcasts and recorded telephone
messages. The world of *Everybody's Gone to the
Rapture* is an intricately observed re-creation of a rural
village in the summer of 1984. The game's creators
recall that their childhood in those years was infused

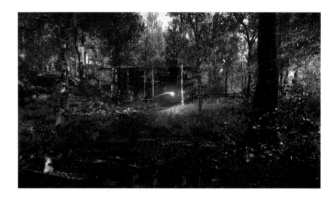

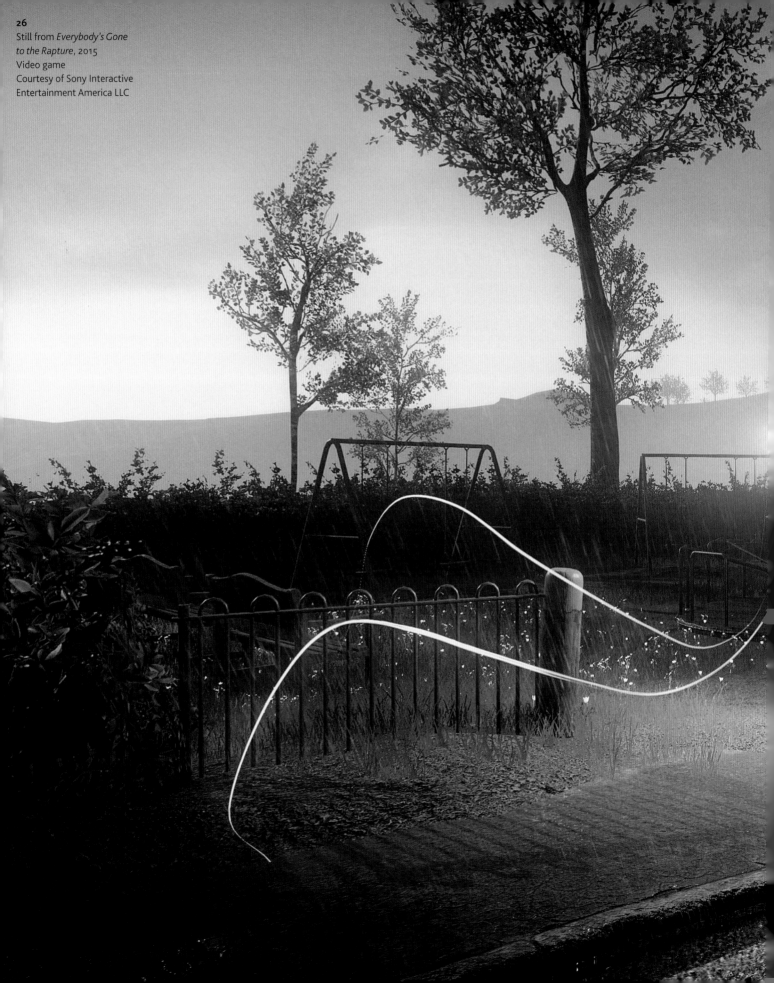

26
Still from *Everybody's Gone
to the Rapture*, 2015
Video game
Courtesy of Sony Interactive
Entertainment America LLC

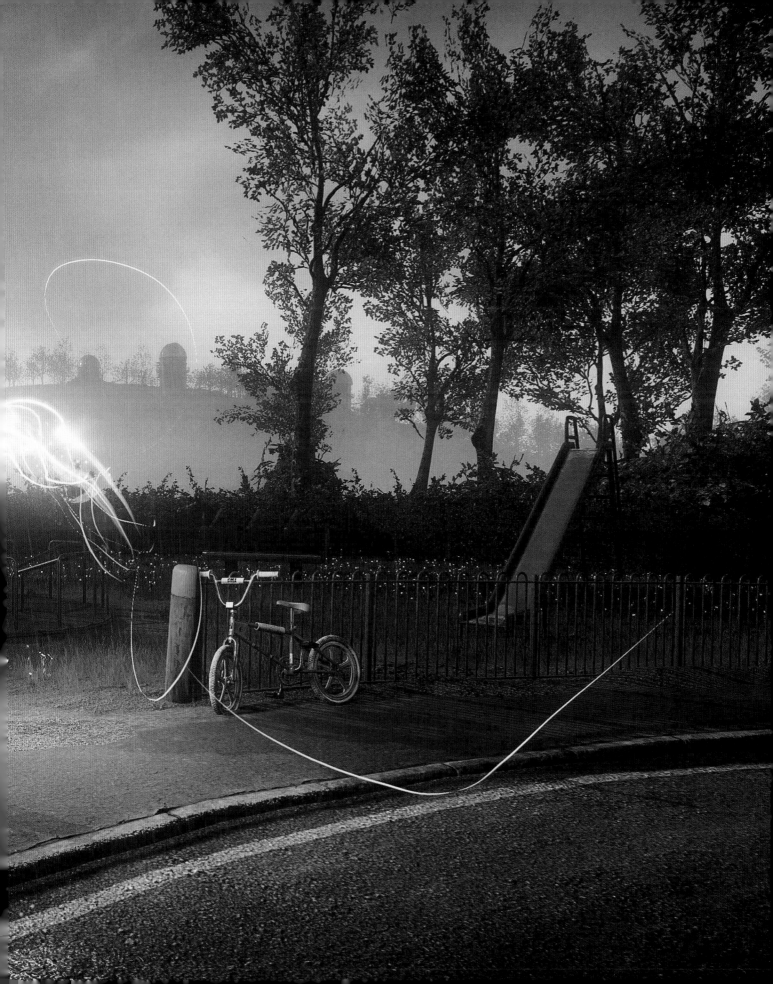

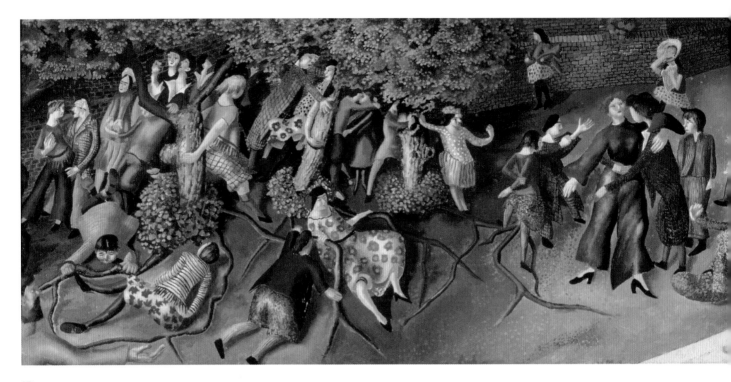

**27**
**SIR STANLEY SPENCER**
*A Village in Heaven*, 1937
Oil on canvas, 43.5 x 183.5 cm
Manchester Art Gallery/Bridgeman Images
© The Estate of Stanley Spencer 2009

with the threat of nuclear attack – an atmosphere that textured everyday life at this time and found cultural expression in TV programmes like *Threads* (1984), *Edge of Darkness* (1985) and *When the Wind Blows* (1986).

When placed in the context of such pastoral sci-fi, *A Village in Heaven* by Stanley Spencer (1937; fig. 27) takes on a different layer of meaning: here the villagers have literally gone to the rapture. The piece depicts residents of Cookham, the village where Spencer lived most of his life, being welcomed into Heaven by Jesus. It is full of realistic detail – the war memorial, flint walls and floral dresses – however, as in many of Spencer's works, the figures seem to be sleepwalking or recently awakened from a dream. They dance, embrace and parade, with stiff limbs and blank faces. It is perhaps no surprise that Spencer chose to depict Heaven as a village. On leaving the Slade School of Art in London and returning to Cookham he described it as 'a kind of earthly paradise'.[4]

## THE OLD WEIRD RURAL

In his classic text *The Country and the City* (1973), Raymond Williams lists the cultural associations that have gathered around these terms. He notes that: 'On the country has gathered the idea of a natural way of life: of peace, innocence, and simple virtue', then goes on to add that: 'Powerful hostile associations have also developed ... on the country as a place of backwardness, ignorance, limitation'.[5] These hostile associations have exercised great power in the popular imagination and contributed to the growth of a genre of rural or folk horror, including TV plays like *Robin Redbreast* (1970) and the film *The Wickerman* (1973). Both of these stories relate to the popular mythology that pockets of strangeness still exist in rural places, where sinister traditions relating to forgotten or unrecognizable agrarian roots continue to be practised.

The reality of encounters with such traditions is the subject-matter of photographs by Homer Sykes and Anna Fox. Sykes embarked upon a tour of the

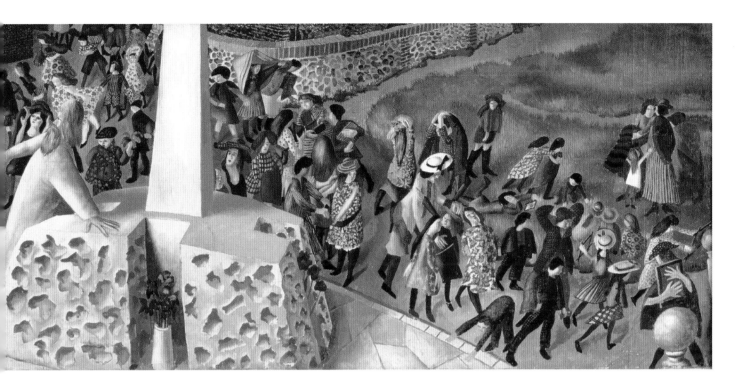

country in the 1970s resulting in a photo series called *Once a Year*, full of images that reveal the strange visual cultures associated with these events (figs. 28 and 29). The Burry Man costume, for example, transforms its wearer into a human cactus stuck head to toe with sticky burrs and topped off with a flowered hat, while participants in the Allendale Tar Barrel Parade don sinister white hoods and carry barrels of tar set alight on a dark winter's evening. Although rooted in folk culture, Sykes's images take us beyond an easy reading of the old weird rural by situating these festivals within everyday contexts. The Burry Man's disconcerting appearance is undercut by catching him taking a drink in one of the pubs he visits on his walk through South Queensferry. He is further brought down to earth or re-humanized when we realise that, owing to his awkward costume, he has to drink through a stripy straw from a glass held by one of his attendants.

Anna Fox's series *Back to the Village* (ongoing from 1999) records the calendar customs and performances which punctuate life in the village where she lives (see figs. 41a–b, p. 62). Her images access some of the weirdness of Sykes and earlier photographers like Sir Benjamin Stone, but the costumes are notably more basic – hastily thrown together – and the participants seem self-conscious. These events seem like echoes of earlier traditions. The more village communities are dispersed, as old families die out and descendants cannot afford to live in houses whose prices have been inflated by middle-class aspirational living, and as connections to the past are lost, the more fervently traditions are enacted, revived and invented. Val Williams says it best when writing about Fox's images: 'These creations, so badly made, so menacing, are ideal subjects for Fox's continuing survey of village life, asserting, as they do, the importance of custom, yet at the same time illustrating its degradations'.[6]

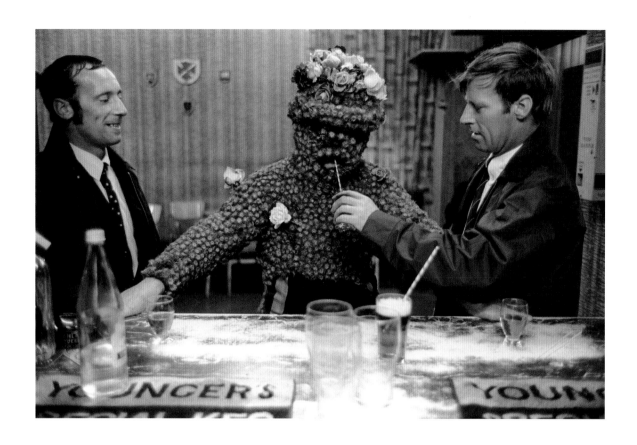

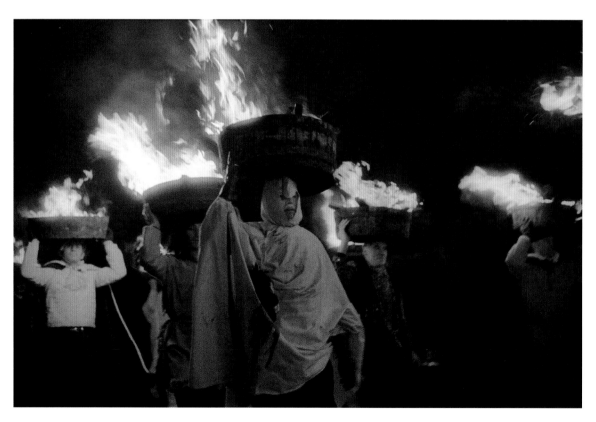

**30**
**LUCY WRIGHT**
*Conversation Hats*, 2013
Mixed media, dimensions variable
© The artist

**28**
**HOMER SYKES**
*Burry Man*, 1971
Vintage gelatin silver print, 24 x 30.5 cm
© The artist, courtesy of The Hyman
Collection, London

**29**
**HOMER SYKES**
*Allendale Tar Barrel Parade, Northumberland,*
*England, Dec 31st 1972*, 1972
Vintage gelatin silver print, 24 x 30.5 cm
© The artist, courtesy of The Hyman
Collection, London

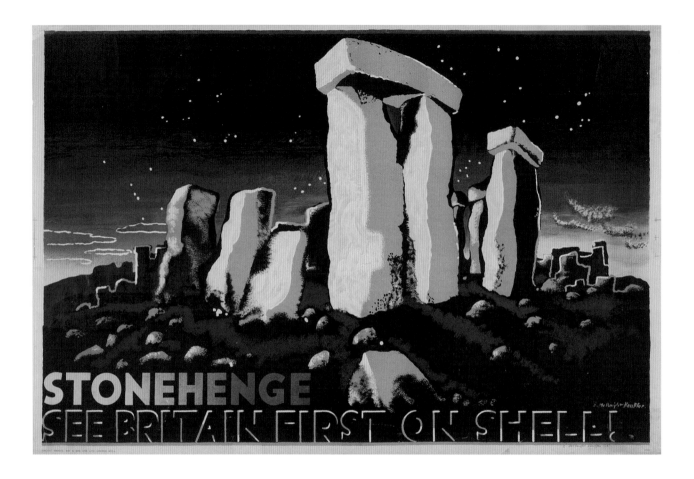

Part of this performance of the picture-perfect English village might include a side of Morris dancers performing at the local pub. This practice is investigated by Lucy Wright, who has created many collaborative projects with different forms of folk dancing. Wright's work expands the idea of what constitutes Morris, exploring the histories and new evolutions of the genre. She has worked with traditional Morris sides and the new wave of girls troupe dancing which finds its roots in the popular town carnival movement in northern England. Often centred around the creation of costumes for performances, like her wildly exuberant *Conversation Hats* (2013; fig. 30) made for Lymm Morris dancers, Wright uses the designing and making process as a catalyst for exchanges about the histories and contemporary meanings of these festive forms.

## THE GREAT ESCAPE

The notion of escaping from crowded and polluted cities into the countryside has been with us since at least the sixteenth century, when rich Italian families built country properties in which to escape the plague-invested metropolis.[7] The idea that the countryside is a health-giving remedy for our over-taxed minds and an essential goal for the upwardly mobile or retirement rich has been mythologized in reality TV property shows and commercialized through interior design and lifestyle magazines – James and Suki have given up their careers in the city to start an organic goats' milk soap business in Wiltshire etc. Perhaps most obviously it has created a thriving tourist industry.

In the 1930s the Shell Oil Company took advantage of the increase in private motor-car ownership amongst the middle classes and produced a series of county guides. Many of the original guides were

**EDWARD MCKNIGHT KAUFFER**
*Stonehenge: See Britain First on Shell*, 1931
Colour lithograph, 74.3 x 111.2 cm
Victoria and Albert Museum, London
©Simon Rendall

edited by important artists of the time, including Paul Nash and John Piper. They valorized heritage details, vernacular architecture and what they deemed to be unspoilt landscapes. Somewhat paradoxically, while encouraging motor tourism, the guides often complained of the increase in visitors to the countryside and the trappings of tourism such as roadside tearooms and advertising signage.[8] Shell branded itself as pro-countryside, and supported a move by the Campaign for the Protection of Rural England to reduce the amount of roadside advertising by putting the company's bill boards on to their delivery wagons rather than displaying them at petrol stations. Thus the lorry bill was created and more artists were recruited to produce landscapes to be used as advertising imagery (fig. 31). Through the county guides, lorry bills and advertising copy disguised as natural history, Shell managed to create an unusual and somewhat contradictory corporate identity, at once a mixture of modern art, innovative motor technology, the countryside and the love of old places and things.

Not to be left out, the industrial working classes also made weekend escapes to the country by train or on foot. Often coming together in hiking or cycling clubs, frequently with socialist leanings, they campaigned for free access to the most spectacular parts of the country, where routes were often closed off by landowners keen to preserve their grouse moors. The famous Kinder Trespass of 1932 contributed towards a prolonged campaign for the right to roam, which formed the foundation for the national parks created under the postwar Labour government in 1951 – a moment with the ambition to make the countryside accessible to all.

**THE END OF THE RAMBLE**
And so we come to the end of our journey through the countryside, passing through grand estates, picturesque scenes, farmland, villages and parks. The idea of the countryside and its visual representation as landscape comprises the view and the peasants, the outside and the inside. It is life and death, it is work, anxiety, beauty, change, isolation, weirdness and prestige. It is always both a cultural construction and a collection of real places – real places rich with their own histories, geologies, ecologies, communities, problems and joys. To quote W.J.T. Mitchell, landscape is 'both a frame and what the frame contains'.[9]

NOTES

1  Raymond Williams, *The Country and the City*, Oxford: OUP, 1973, p. 120.

2  Christine Boydell, *Horrockses Fashions: Off-the-Peg Style in the '40s and '50s*, London: V&A Publishing, 2010, p. 143.

3  Tom Normand, 'A Realist View of a Victorian Childhood: Re-reading James Guthrie's "A Hind's Daugher"', *Scotlands*, vol. 4, no. 2, 1998, pp. 41–52.

4  Fiona MacCarthy, *Stanley Spencer: An English Vision*, New Haven and London: Yale UP, 1997, p. 13.

5  Williams 1973, as note 1.

6  Val Williams, *Anna Fox: Photographs 1983–2007*, Brighton: Photoworks, 2007, p. 216.

7  Malcolm Andrews, *Landscape and Western Art*, Oxford: OUP, 1999, p. 58.

8  See David Heathcote, *A Shell Eye on England: The Shell County Guides 1834 – 1984*, Faringdon: Libri Press, 2011.

9  W.J.T. Mitchell, *Landscape and Power*, Chicago and London: University of Chicago Press, 1994, p. 5.

# REBECCA CHESNEY

**Rosemary Shirley (RS): Your work *Snapshot*, which looks like a paint chart, complete with names and descriptions for each coloured square, was made in response to time spent in the Brecon Beacons National Park. Can you tell me about its relationship to this landscape?**

Rebecca Chesney (RC): It came out of earlier conversations we had and about the range of air fresheners that are themed around the UK's national parks. It annoys me the way people romanticize the rural and I think that's really influenced my work. I come from

a rural area and people make assumptions about me, for example that I might be from a farming background. The air fresheners feel like one of these assumptions; they speak of the absurdity of describing the rural in very simplistic ways. I wanted *Snapshot* to be a much more detailed account of a landscape than just one smell could ever be. It has 96 colours, each sourced from photographs of the landscape. Each one has a name and a description.

One of my first impressions of the Brecon Beacons is that it is quite beautiful, but it's one of those combinations between

old, quite run-down farms and an ageing population of farmers, together with a middle-class cosy cottage aspect, but it is all part of the same view. I tried to incorporate the beauty of the landscape, but also the ecology and the geology that make it unique, together with other issues that are part of the place like affordable housing, farming as an industry, economic and environmental factors. For example, the colours *Usk in Flood* and *Swollen* are both about the high rainfall we experienced last winter, whereas the colour *Heather Habitat* refers to the climate and growing conditions required by certain

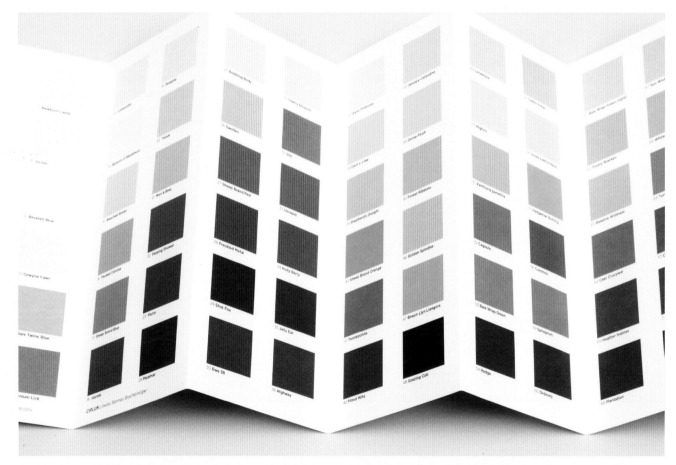

*Snapshot, Colours of the Brecon Beacons*, 2016
© The artist

mountain-top species. Those conditions are changing, everything is warming up and there's nowhere higher for these plants to go, so things like spagnam moss, heather, bilberry, and quite rare alpine species that don't survive lower down the hill – we're going to lose them. The chart is designed in a landscape format, and as you unfold it all these different aspects of the landscape are represented.

**RS: Are there some colours in *Snapshot* that might seem surprising?**

RC: It was hard not to have more negative things included in the piece because they often stand out in the landscape. There's quite a lot of death in it, like the colours *Bobbing Body* and *Pecked Carcass*, but if you are going to have a landscape that is dedicated to livestock then you are going to encounter a lot of death. I was there during lambing and it's a fraught time; there's birth and renewal but there's also death and sometimes I think we sanitize the landscape a bit. Because I was in the Brecon Beacons in winter, the landscape is laid bare in front of you, things aren't covered up by foliage. I don't know if people are a bit surprised about the references to rusty vehicles and plastic in the piece, but it is all there in the landscape.

**RS: These things are often present in rural landscapes but somehow invisible.**

RC: Yes, like the bails of silage which are covered in plastic, sometimes black sometimes green. If there were a sculpture that big in the landscape there would be an outcry. There's not a campaign to get rid of them as there is for wind turbines – people see past them or beyond them. I think it is funny that they make the bails green, as if they will blend in. There are three different

colours in the chart that are taken from bail wrap, one black and two green.

**RS: Your process for making *Snapshot* was to walk in the landscape by yourself, and I just wanted to ask how that felt?**

RC: Sometimes I had to make myself do it. I was in a remote working valley and I did feel like I was a visitor, an intruder, I felt like I was taking photos of someone else's space. I did feel a bit uncomfortable sometimes – dogs are barking in that valley the whole time, they might be miles off but it feels like an aggressive thing. Then there is the low grumble of quad bikes, you can't see them but you know they're in the valley somewhere. I felt like a visiting female in the landscape; however, I am always determined to just keep going. Some of the public footpaths I walked on had not been used for years, they were blocked and sometimes flooded and I had to wade through in places. I felt I was creeping about on someone else's land, which I suppose I was.

It wasn't always like that, though, I also went up some of the really well known paths and they were heaving even in January, in all sorts of weather conditions. There were loads of people in shorts as the snow was blowing in, so busy – like a highway. The national park have had to make massive paths for them, and there's a huge car park for one hill, Pen y Fan. But I joined them, I went on the same walk and did the same thing as all the visitors, so I added to that.

**RS: A lot of landscape painting and literature sets us up for the idea that going out into the landscape is going to yield some sort of spiritual or sublime or life-changing experience, but quite often there is a feeling of being crowded out or intimidated or just a bit uncomfortable or on edge.**

RC: We've been sold one set of images saying we should enjoy the rural experience and another saying we should be frightened. Abandoned houses, creaking doors, and forests, from fairy stories to rural horror. But then ruins were also seen as part of the picturesque – the tumble down barn is romantic. *Crumbling Barn* is the name of one of the colours in *Snapshot*; it refers to the affordable housing issues in the area and some of the rules around the development of barns.

**RS: Your piece *Death by Denim*, which takes the form of a set of artefacts relating to the production of a range of denim walking gear, also draws on the idea of the landscape as having a dark side or being quite dangerous.**

RC: When I moved back to Lancashire I got in with a group who went out walking in the Lake District and I thought I'd like to join them but I had no walking gear, just an old pair of walking boots. I turned up in jeans and they kind of scoffed at what I was wearing – 'You shouldn't be wearing jeans, it's not good for you, if they get wet they get heavy and cold'. My response was that 'I don't think there's officially been any death by denim in the landscape'. This was around 1999, but every time I went walking in the Lake District I'd think about the acceptability of certain clothes amongst the walking fraternity. It is obviously better if you have a lighter pair of trousers when you get caught in the rain but at the same time there is a snobbery attached to it – I'm better equipped than you, I know more about mountains than you, because I've got the proper gear: I'm prepared, you're not.

I realise that there have always been deaths in the mountains, but I wonder if it is just walkers in all the 'proper' gear [who die]? All the ones in the jeans and trainers are at home in winter watching television

## Lakeland Sun

# DEATH BY DENIM

**34a**
*Death by Denim*, 2015
*Lakeland Sun* headline,
Tuesday 17 July 1973

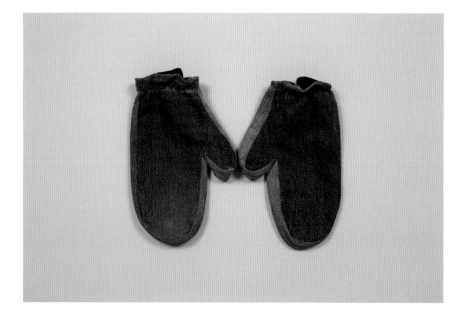

or shopping or something, but when you have all the gear maybe you think you are invincible. So I invented the first 'death by denim' and I loved making it up. The piece could only work because I was drawing on all those existing mythologies. When it was first exhibited, people didn't know it was all made up, and I'd get visitors telling me stories in disgust: 'Well I saw someone up one of the mountains in the Lake District wearing Ugg® boots'. They probably could have broken their ankle, I get it – but everyone fell for *Death by Denim* because it draws on the preconceived ideas about who belongs in the landscape, the markers of that belonging, and an ingrained fear of the power of certain landscapes.

**RS: Your work often involves elaborately constructed fictions, why do you adopt this way of working to explore themes of landscape, nature and the environment?**

RC: I think a lot of our knowledge of nature is based on folklore myths and legends. Much of the naming of plants continues to be based on folklore; the knowledge of that folklore might not exist any more but the names remain. I became interested in the way these stories might influence perceptions of rural places. There was a tipping point with a piece of work I made. I wanted to do a core sample from a field to show that there were many different layers and elements underneath this beautiful meadow. However, the authorities wouldn't let me do it for all sorts of health and safety reasons, so I faked it instead. Not only did I make a fake core-sample, I encased it in lead and said that it contained super-toxic substances. I realised at this point that I could do whatever I wanted as an artist. I started presenting ideas as if they were fact. I've since realised that the boundaries between truth and fiction get further blurred when doing online research. Potentially anyone can put anything online: purported facts are cut, pasted and repeated, but often you can never find the root or the original piece of work that is being quoted. So I realised I could do that, I could create my own facts. Truth and fictions sit side by side in my work. Everything in *Snapshot* is true, it's a serious project, but when you put it next to *Death by Denim* you realise that it is exploring the same issues just in different ways. The two support each other.

**34b**
*Death by Denim*, 2015
*Summat* mittens
Scoglio & Son of Bolton 1973

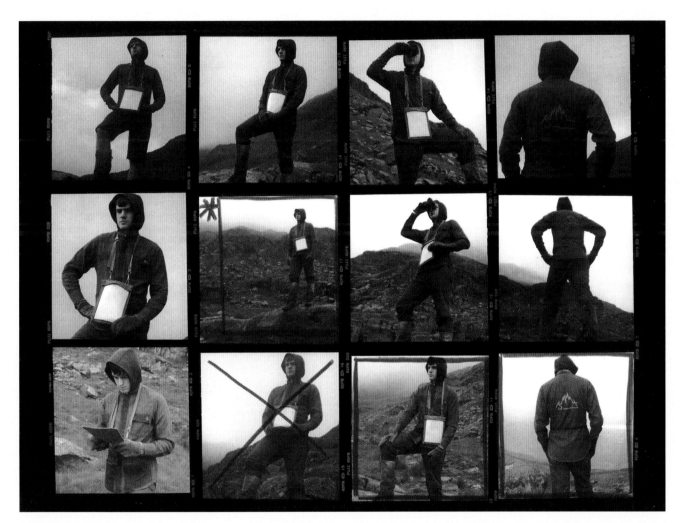

**34c**
*Death by Denim*, 2015
Contact sheet from the *Summat*
fashion shoot, 1973
Model unknown
Courtesy of the Scoglio family

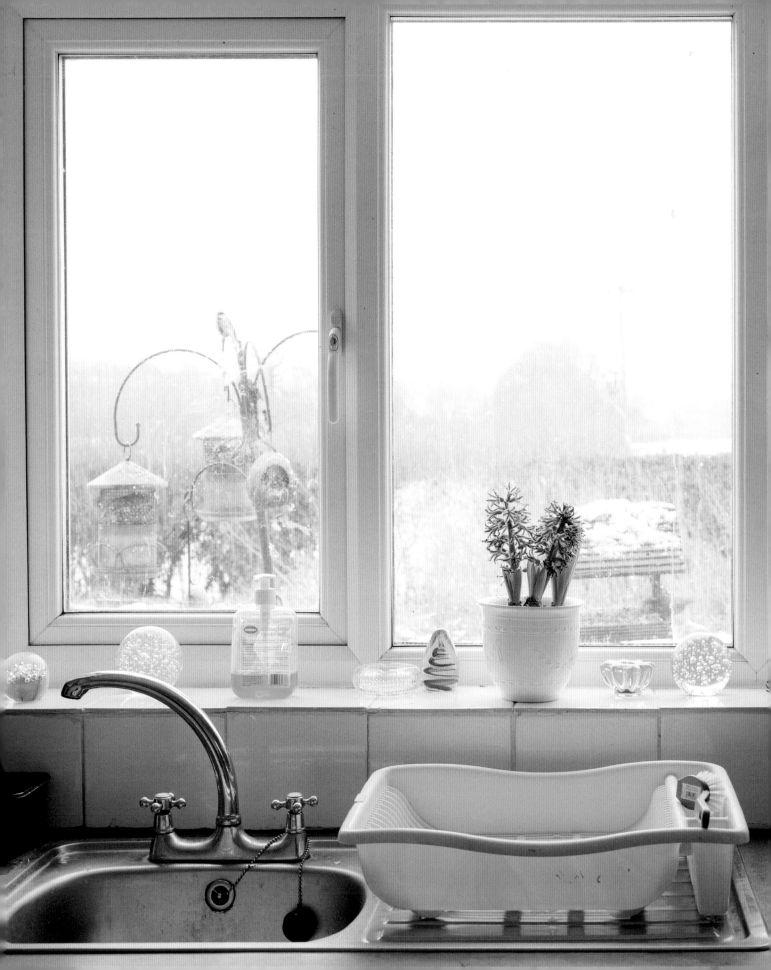

# 'Let's discuss over country supper soon'
# Rural Realities and Rustic Representations

NICK GROOM

On 14 June 2012, the Leveson Inquiry learnt of a text message sent on 7 October 2009 by Rebekah Brooks, recently appointed Chief Executive Officer of News International (having previously edited *The Sun*), to David Cameron, on the eve of his speech as leader to the Conservative Party Conference. *The Sun* had just endorsed Mr Cameron as a future Tory Prime Minister.

But seriously I do understand the issue with the *Times*. Let's discuss over country supper soon. On the party it was because I had asked a number of NI [News International] people to Manchester post endorsement and they were disappointed not to see you.

But as always Sam was wonderful (and I thought it was OE's [Old Etonians] were charm personified!) I am so rooting for you tomorrow not just as a proud friend but because professionally we're definitely in this together! Speech of your life? Yes he Cam

It was that phrase 'country supper' that galvanized commentators in the press. Just four months before she sent this message, Rebekah Kemp had married Charlie Brooks, an Old Etonian – like Cameron – and a friend of Cameron's brother Alex. Both David and Alex attended the Brooks's wedding. And Mr and Mrs Brooks then settled in Chipping Norton – to become

part of the same Cotswold country set as the Cameron couple David and Sam. The groaning pun signing off the text was to be expected from a former editor of *The Sun*. But the intimacy of the phrase 'country supper' shifted this cosy relationship into a new realm.

As Jonathan Freedland commented the next day in *The Guardian*, 'The phrase is delicious, concisely capturing the entire culture and chumminess of the Chipping Norton set, its elite habits and its remoteness from the way most people are living in austerity Britain'.[1] On the same day, Hugo Rifkind wrote in *The Times*, 'Country supper. What's that, then?' Rifkind reminded his readers of Francis Maude's revelation that the Camerons had an appetite for 'kitchen suppers' at Number 10 with Conservative Party donors:

That didn't make sense either, because for the vast majority of British families, who struggle by without a dining room, a 'kitchen supper' sounds a lot like 'supper'. In this context, supper is probably best defined by what it is not. It's what you have if you could be having dinner, but aren't …. Then, as far as it can be said, a country supper is a kitchen supper you have in the country, which you can have only if you possess a dining room you are choosing not to eat in, and another home in town which you are not at. For ease, you should probably just call it an Aga supper. Unless you've got a Rayburn, in which case things get complicated.[2]

A discussion board at the *Times Education Supplement* revealed that 'country supper' was not

a familiar term.³ An anonymous journalist writing in *Tatler* subsequently attempted to define the 'Great British Country Supper' by comparing it with dinner etiquette: 'There isn't a placement and the conversation is spoken across the table (rather than to left or right) .... With any luck, the occasion will be interrupted by a mild calamity – a power cut, a bird flying down the chimney, someone forgetting a child – that can quickly be solved with lots of squawking and self-congratulation.'⁴ 'Country supper' on these terms was power politics as omnishambles: 'The fight is now on to show how easygoing, even shambolic, entertaining can be' – although I doubt that *Tatler* would include the arrest and likely imprisonment of the hostess as part of the fun. But the writer did note that 'The country supper is a rural practice adopted by successful Londoners who want to form discreet coalitions'. Doubtless because of *The Sun*'s reputation for salaciousness, *Tatler* suggested that there were two types of 'country supper': after coffee, the 'Sloane Ranger country supper will move into strip poker, then into dancing on chairs and tables ... [and later] they'll all go upstairs for a light orgy', whereas at 'the powerhouse country supper, there will be only light inebriation (sometimes faked) and no spontaneous sex at all'. Michael White in *The Guardian* also suggested a more carnal meaning: 'Rebekah's "country suppers", evoking Shakespeare's "country matters", suggest a brazen ambiguity that can take people far'.⁵ (The reference is to Hamlet's bawdy innuendo with Ophelia when he imagines lying between a maid's legs. In this *context*, one might say, I cannot resist mentioning the 'Uxbridge English Dictionary' round in the long-running Radio 4 series *I'm Sorry I Haven't A Clue*, in which words are given new definitions. On one occasion another tabloid newspaper editor was mentioned in the definition of 'countryside': 'killing Piers Morgan'.)

For all this speculation, Ben Fenton in the *Financial Times* revealed that 'country supper' was 'well known in the US, denoting a meal enjoyed in a farmyard to the accompaniment of "country" music'.⁶ Sadly this is not the case here. But Fenton offers the sharpest analysis of the phrase, pointing out that it 'resonates with connotations of elitism, political influence and cloying familiarity' and instantly 'chimed with the UK's mood of distaste for its ruling classes ... revealed daily by the phone hacking tribunal':

The words crystallized an imagery of the private lives of the rich and powerful. It summoned up a scene of big business and high politics *tête-à-tête* in one of those settings as familiar to readers of Joanna Trollope: a carefully casual meal eaten on an expensive distressed oak table just within reach of a kitchen the size of a small parish.

All this is so much journalistic pepper. But Fenton concludes with a broader point about the country and city:

Real 'country set' people – such as Mr Cameron, a gentry man raised in Berkshire – would never use a term that differentiated rural from urban life. The differentiation is assumed. To make such a distinction betrays a reliance placed upon the meal as an opportunity to exert influence, to exploit familiarity and to enjoy the privacy of the *crème de la crème* ....

'Country supper', in other words, is a phrase that sentimentalizes rural life through food in order to politicize it. In addition it aestheticizes power by consumption and the rituals that surround it.

Brooks dropped the definite article 'a': she did not write 'Let's discuss over *a* country supper soon', but

'Let's discuss over country supper soon'. 'Supper' is of course of Anglo-Norman rather than Anglo-Saxon derivation, and so already has connotations of both oppression and Continental sophistication (the distinction between Anglo-Saxon 'sheep' and Norman 'mutton', the acculturated dish, displays similar associations). It also has Christian overtones – the 'Last Supper'. 'Supper' does not (yet) appear with the article 'country' in the *OED* (although it can hardly be long before it does). It is often the second element of compounds that refer either to content – such as 'meat supper', 'oyster supper', 'sandwich supper' and so forth – or to time or to place – in 'nursery supper' or 'Sunday supper'; or to social events such as 'buffet supper', 'Dutch supper', 'fork supper', 'picnic supper' and 'tray supper'. There is also familiar folklore surrounding supper, as there is with other examples of dining and sharing food: 'to sup with the devil' is defined as 'to go to hell; to do something that has disastrous consequences'. 'Country' is a word quite complicated enough without having to quote Raymond Williams, but for present purposes the *Dictionary* definition identifies the country as:

> Of or pertaining to the rural districts; living in, situated in, belonging to or characteristic of the country (often as contrasted with the town); rural, rustic: as in country bank, country boy, country breeding, country bumpkin, country carpenter, country carrier, country church, country clergyman, country cottage, country fellow, country gentry, country girl, country labourer, country manners, country parish, country pleasures, country reader, country school, country sport, country squire, country tailor, country trader, country village, country wake, country wench, country work, etc.[7]

Not 'country supper' – but then I am arguing that 'country supper' does *not* pertain to rural districts. The 'country' of 'country supper' is a metropolitan appropriation, an urban fantasy of country life.

Consequently, 'country supper' is an aspect of the contemporary pastoral. We live in a culture that idolizes the pastoral – not the classical pastoral of Virgil, or the Renaissance pastoral of Edmund Spenser, or the scientific pastoral of James Thomson. Rather, today's pastoral is seen in newsagents and on the small screen. There are dozens of glossy magazines on country living, books on escaping from the city, and television programmes on the countryside – anything from wildlife documentaries to situation comedies and murder mysteries. 'Country supper' is, however, a particularly telling example of contemporary chic pastoral: it reduces the entire English rural economy, as it were, to the contents of a Le Creuset casserole dish cooking slowly in an Aga. It has been estimated that one new person moves to the country every five minutes. What do they find there? National Trust members outnumber farm workers by seven to one. In 1995 Britain imported 26% of its food; it now imports 40%. On average, three dairy farmers quit farming, and four pubs now close, every day.[8]

This population migration, comparable to the seismic shifts of the Industrial Revolution, is bringing with it a new form of extinction: the eradication of the local and its replacement by mega-retailers and superstores. Country towns, villages and farming are being colonized by urban economies that create clone towns and clone countryside. The high streets of market towns are homogenized, and rural England disappears under out-of-town developments and industrialized agri-business. The most salient characteristic of today's England is the erosion of identity in totalitarian shopping complexes – what the writer and activist Paul Kingsnorth calls the

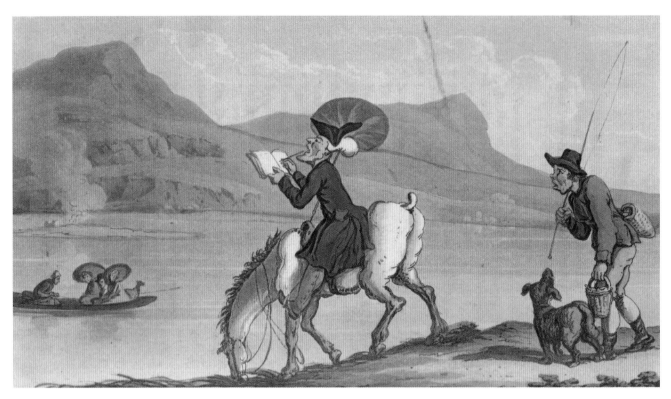

36
**WILLIAM COMBE**
'Dr Syntax sketching the lake', from
*The Tour of Dr. Syntax, in Search of
the Picturesque, a Poem*, London, 1817
© The British Library Board,
Shelf Mark: Cup.410.g.425

'Bluewatering of England'.[9] We are witnessing the wholesale destruction of heritage and character and traditional meeting-places by chain stores and supermarkets – the annihilation of our communities through what could equally be called Tescofication. The migration to the country, mostly by the newly wealthy who can afford to maintain a second home in rural surroundings, is eroding any distinction between country and city – indeed, the distinctions that once appeared to give the pastoral meaning perhaps no longer really exist at all, as the English countryside now becomes the conservatory of the urban.[10] And still the land is sentimentalized: how many weekenders will complain about dung in the road, church bells ringing and sheep in their gardens? We need to re-evaluate this contemporary pastoral and

start rethinking what we understand by the English countryside.

The pastoral emerged through the influence of Petrarch and other Italian poets on English writing to produce a genre that was then politicized by Spenser, Shakespeare and Michael Drayton – Shakespeare's *As You Like It* (1599–1600) being the most sophisticated examination of not only the penetration of metropolitan culture and politics into the countryside, but the maintenance of a rural region precisely for such a purpose. The harsh realities of rustic life were seldom discussed, and there was little sense in much English pastoral poetry of the discontent of the peasantry or of rebellion inspired by the shift from feudal to early capitalist economies.[11] Nevertheless, on my reading at least, Shakespeare

makes it clear that hard work for the many meant leisure for the few.

Drawing on Virgil, Spenser and Drayton – if less on Shakespeare – James Thomson's best-selling eighteenth-century poem *The Seasons* (1736–40) deliberately tied the landscape to national identity, which had been a political hot potato since the Act of Union between England and Wales, and Scotland in 1707. Thomson, who was Scottish, deliberately wrote the poem as a celebration of the newly minted Britishness, and *The Seasons* was a key text in uniting Britain. It focused on instances of common endeavour – wealth, commerce, liberty and law; patriotism and prosperity; the Empire and the Navy; the register of British Worthies; the progress of recent political history; and the ancient (if fabricated) history of bards and Druidic groves. This georgic patriotism was certainly recognized at the time: the writer and physician John Aikin argued in the 1790s that 'a taste for nature is said to be equivalent to a love of liberty and truth'.[12] Thomson, lest it be forgot, wrote not only the political poem 'Liberty' (1735–36) but also the imperial anthem 'Rule, Britannia' (1740).

As a celebration of Britain and the British countryside, Thomson's *Seasons* is hard to beat. It not only cultivated the ever-present eighteenth-century impulse to celebrate trade, colonial expansion and the national interest, but also helped to inspire the sensibility of leisure – the tendency to treat the countryside as a huge park for middle-class and aristocratic outings. There was no sympathy with the plight of the rural labouring class: they are as absent from Thomson's poem as, by and large, is any reference to rustic culture, festive traditions, agricultural proverbs, weather lore, saints' days and the entire framework (which was then still robust) of the sacred year. For all the accumulation of empirical and perceptual detail, there is virtually nothing on the annual rural cycle. *The Seasons* therefore presents a vision of England devoid of its agrarian workforce: it is a poem that removes rural people from the countryside. Why? Because *The Seasons* is an anthem to improvement and progress, a hymn to the agrarian revolution and entrepreneurship. Thomson's vision was realised within two or three generations by a landslide of Enclosure Acts, which physically removed many of the unimproved common people from the environment that had supported them – forcing them in due course towards the newly industrial cities. Agricultural labourers, their homesteads and their communities were changing forever.

Enclosure and landscaping achieved an idealized, pastoral encapsulation of a countryside unperturbed by the inconvenience of the rural classes, and undisturbed by the arduousness of their work, the celebration of their culture or the expression of their needs. They were painted out of this landscape, first by pastoral poetry, then by the politics of enclosure. The picturesque was another eighteenth-century vogue. It espoused the primacy of art, declaring that nature should aspire to the condition of a painting. If rather less subtle than the pastoral's proposition that the countryside should be read in terms of a bucolic genre of literature, both the picturesque and the pastoral imply that nature is somehow wanting. Every time you look at a sunset on holiday and remark that it is just like a postcard, or survey a hilltop view and mentally compare it with a landscape painting, you are revealing how indebted you – and indeed all of us – are to the eighteenth-century picturesque.

The effect of the picturesque was to rework the natural world into a 'landscape' – a word that came to England at the end of the sixteenth century from the German, via the Dutch.[13] Early English uses of 'landskip' are strongly cultural: the word is used to describe paintings, particularly the backgrounds

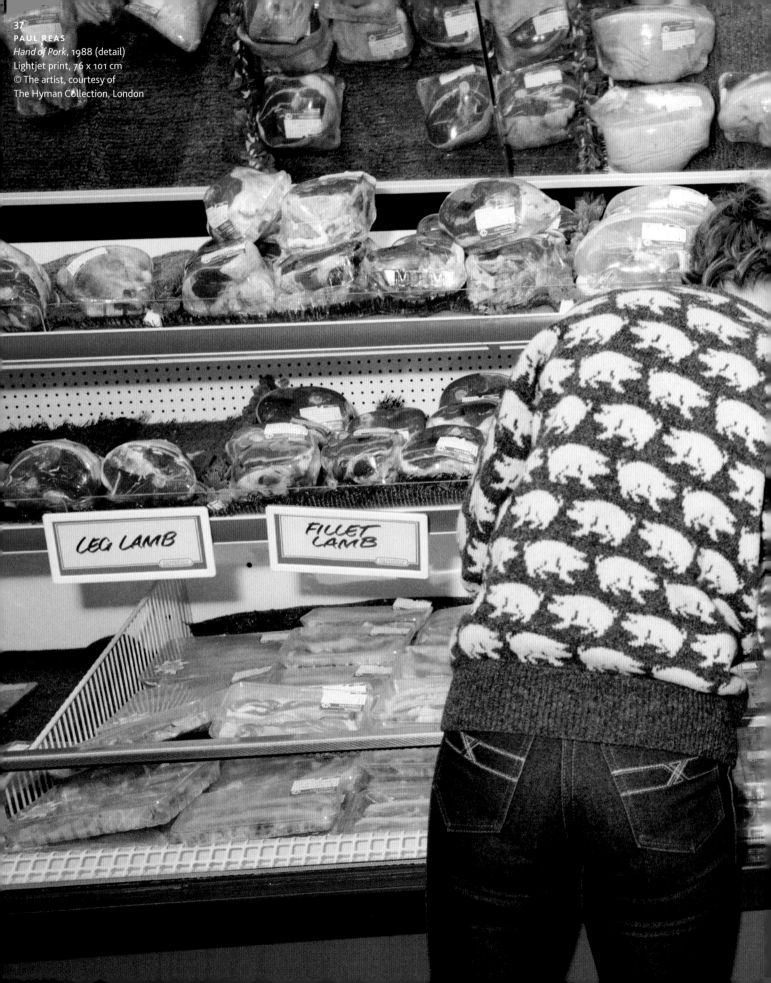

LEG LAMB

FILLET
LAMB

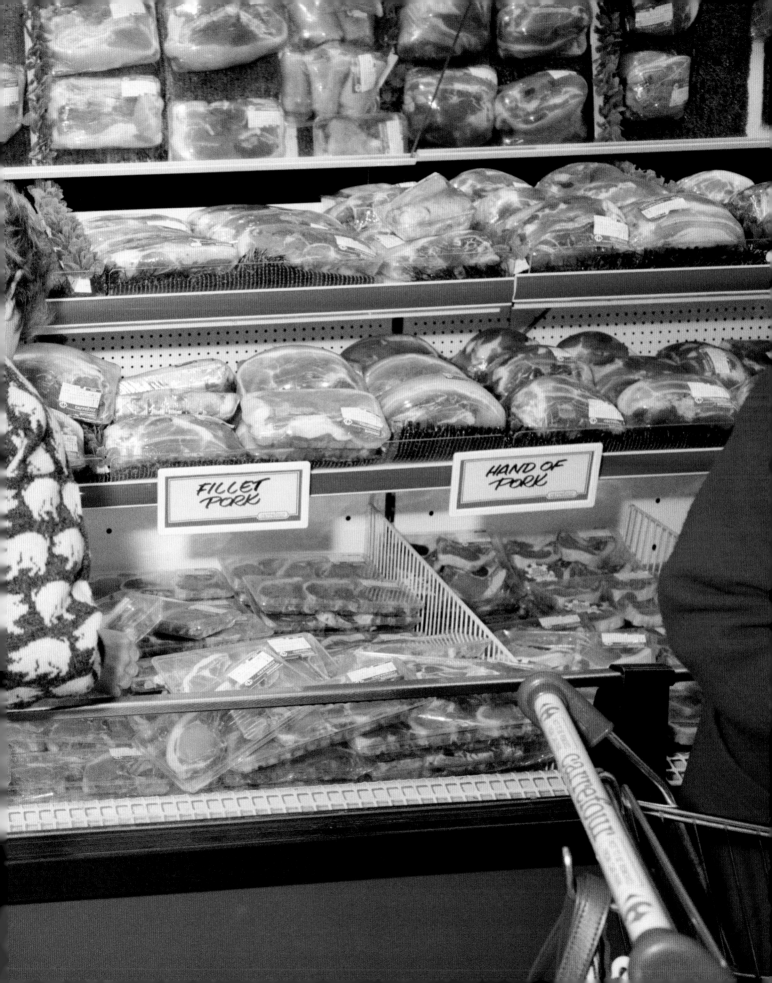

FILLET PORK

HAND OF PORK

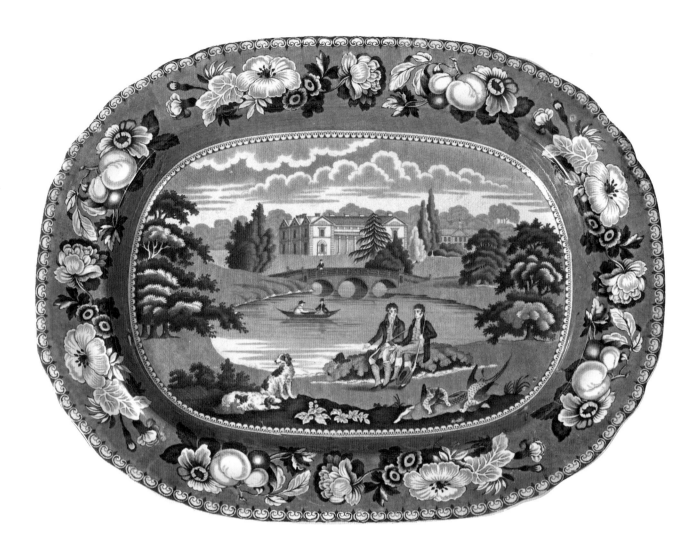

of paintings, and thereby any view that could conceivably be painted. For the lexicographer Thomas Blount in 1656, the 'landskip' was a frame to the main subject of a painting: it was the

Parergon, Paisage or By-work, which is an expressing of the Land, by Hills, Woods, Castles, Valleys, Rivers, Cities, *&c.* as far as may be shewed in our Horizon. All that which in a Picture is not of the body or argument thereof is *Landskip, Parergon,* or by-work.[14]

The picturesque encouraged the critical appreciation of nature as a spectacle. Observers of a scene – the word 'scene' itself reveals the implicit theatricality of viewing – became an audience,

by turns appreciative or critical. Hence natural landscapes became part of culture, and were understood, judged and painted according to artistic conventions and aesthetic theories. For a growing proportion of the increasingly urban population, initial encounters with natural landscapes would be through the medium of art – representations delivered either by pastoral poetry or in picturesque images. So landscapes, both illustrations and real views, were treated as the visual equivalent of pastoral poems, and pastoral poems as the literary counterpart of landscapes – with all that that entailed when it came to perfecting the depiction. As the influential idealist and cleric Claude-François Fraguier put it,

Pastoral Poetry is like a Landskip, which is seldom drawn from a particular Place; but its Beauty results from the Union of several Pieces played in their true Light; in the same manner as beautiful Anticks have been generally copied, not from a particular Object, but from the Idea of the Artist, or from several beautiful Parts of different Bodies, reunited in one Subject.[15]

Reality was just a rough and raw material, necessarily subordinate to 'the Idea of the Artist'.

Consistent with the pastoral, picturesque views did not include scenes of poverty or, for that matter, of labour. They did not include working farms or agricultural fairs, and preferred little or no livestock. In *Observations, Relative Chiefly to Picturesque Beauty* (1786), for example, William Gilpin, the educationalist and leading popularizer of the movement, famously stipulated the ideal number of cows in a picturesque view:

Cattle are so large, that when they ornament a fore-ground, a few are sufficient. Two will hardly combine. Three make a good group – either united – or when one is a little removed from the other two. If you increase the group beyond three; one, or more, in proportion, must necessarily be a *little detached*. This detachment prevents heaviness, and adds variety. It is the same principle applied to cattle, which we before applied to mountains, and other objects.[16]

Cattle and mountains were just so much rustic detail, and of course the ideal number of rural labourers in a picturesque scene, for Gilpin, was no labourers at all. He certainly knew that the countryside was full of people going about their business. He even encountered groups of labourers in Cumbria on one of the year's rent days, and admits 'we were not a little entertained by the simplicity, and variety of the several groups and figures we met'. But they had no place in picturesque art: 'In grand scenes, even the peasant cannot be admitted, if he be employed in the low occupations of his profession: the spade, the scythe, and the rake are all excluded'. What was allowed was pastoral idleness – 'the lazy cowherd resting on his pole ... the peasant lolling on a rock', an angler rather than a fisherman, and gypsies, *banditti*, and the occasional individual soldier in antique armour.[17] The image of the countryside presented therefore looked very much in need of improvement – slack, inefficient, indigent, lawless and archaic. Attention was focused on how to paint a leaf rather than how to represent the disenfranchised, subjugated and pauperized rural workforce. The cult of the picturesque exemplifies how politics can define 'natural' beauty in such a way as to disenfranchise elements of the population.

Moreover, just as pastoral poetry and the cult of the picturesque painting drained history, tradition, and folklore from the seasons and replaced it with a disengaged sentimentality, so English landscape gardening performed the same operation at ground level, and with the same result. Richard Payne Knight's poem *The Landscape* (1794), for instance, a response to William Mason's influential verse *The English Garden* (1772–82), prompted the landscape gardener Humphry Repton to observe that,

The enthusiasm for picturesque effect, seems to have so completely bewildered the author of the *poem already mentioned* [Payne Knight's *The Landscape*], that he not only mistakes the essential difference between the landscape painter and the landscape gardener; but appears even to forget that a dwelling-house is an object of comfort and convenience, for

**39**
JOHN CONSTABLE
*The Cottage in a Cornfield*, c.1817–33
Oil on canvas, 62 x 51.5 cm
© Victoria and Albert Museum,
London

the purposes of habitation; and not merely the frame to a landscape, or the foreground of a rural picture.[18]

Repton recognized the dangers in sentimentalizing tumbledown country cottages as picturesque: such tendencies only encouraged the belief that the rural population were somehow undeserving of solid, and safe, new housing or of gardens they could properly tend. Payne Knight had even deplored cottagers who had the temerity to mow their own patches of turf, as this compromised the picturesque qualities of a scene:

Break their fell scythes, that would these
    beauties shave,
And sink their iron rollers in the wave![19]

William Wordsworth later fell for these dangerous enchantments, even criticizing the colours that houses were painted in the Lake District and calling for restrictions against bad taste as it was measured by the tenets of the picturesque.[20] He effectively succeeded in his campaign. Graded listings for houses, conservation areas and planning requirements in national parks are all consequences of the effects of the picturesque on landscape gardening. The English domestic garden has also been an agent by which the pastoral and the picturesque have become naturalized, and the flourishing English gardening scene is a testament to the seductive power of those stubborn trends now driven by gardening programmes, gardening books, and garden centres.

For Jeremy Burchardt, 'many aspects of rural recreation in the late twentieth century [have] become characterized by a radical commodification in which images [bear] almost no coherent connection to any underlying reality'.[21] The English countryside is thus largely a landscape imagined and therefore to a degree constructed by media of urban society, which since *The Archers* was first broadcast in 1950 has successively reinvented the countryside as ever-renewed versions of English pastoralism. Here the English countryside is less significant in the national imagination as a means of production (that is, of farming) than it is as a place of leisure – ranging from an individual's appreciation of natural landscapes to team sports and mass social gatherings. The countryside is, in other words, something to be consumed.[22] And it is this consumption that is exemplified in the phrase 'country supper'.

Contemporary forms of communication are now taking over from writing, painting and gardening as the primary media for imposing urban values on the countryside and creating an homogenized culture. As urban culture became more and more dominant in the 1950s and 1960s through television and radio, and as agricultural communities declined owing to rural depopulation (arable farming, for instance, had become much more mechanized during the Second World War and so required fewer workers), living in remote rural areas, as Burchardt puts it, 'no longer meant merely accepting a more limited rural culture in place of a more varied urban one, but accepting exclusion from national culture as a whole'.[23] We live in a country of two nations – the urban centre and the rural periphery, but it is the urban media that defines the countryside, through national newspapers, house prices and private text messages.

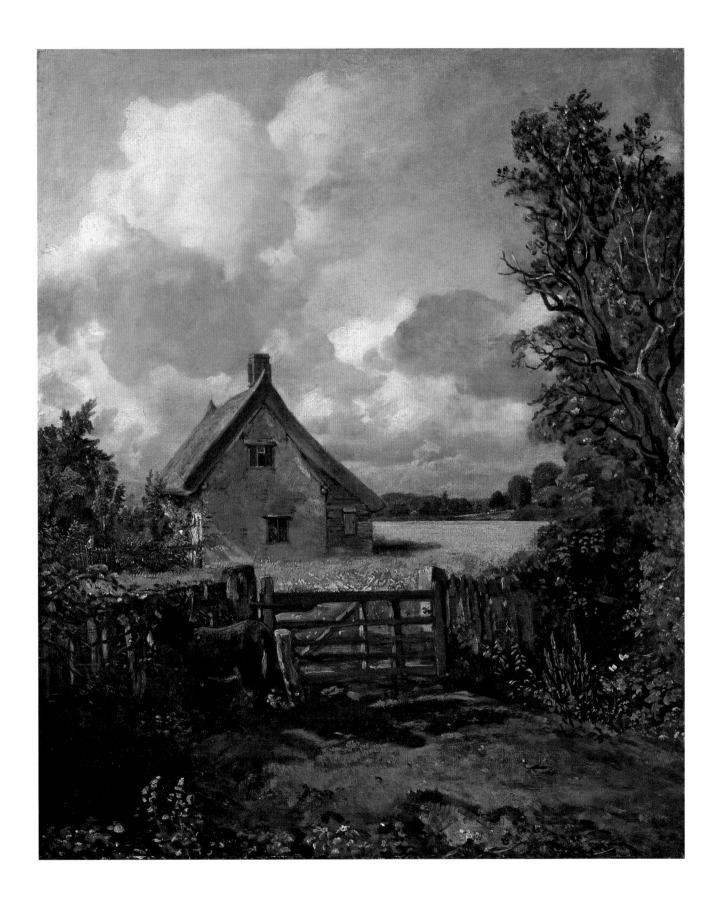

NOTES

1 Jonathan Freedland, 'That Rebekah Brooks Text Message to David Cameron – Decoded', 14 June 2012; www.guardian.co.uk; the text message was sent on 7 October 2009.
2 Hugo Rifkind, 'A Country Supper, What's That?', *The Times*, 15 June 2012.
3 *Times Education Supplement*, 17 June 2012.
4 *Tatler*, 11 Sept 2012.
5 Michael White, 'Cameron's "Country Suppers" Leave Nasty Taste', *The Guardian*, 14 June 2012.
6 Ben Fenton, 'A Year in a Word: Country Supper', *Financial Times*, 27 December 2012.
7 *OED*; see, of course, Raymond Williams, *The Country and the City*, New York: Oxford UP, 1973, and *Keywords: A Vocabulary of Culture and Society*, London: Fontana, 1988.
8 These statistics are also taken from Paul Kingsnorth, *Real England: The Battle against the Bland*, London: Portobello, 2009. This situation does not appear to have improved since Kingsnorth's book was published. For example, the *Financial Times* reported on 21 March 2016 that 'Almost 1,000 dairy farmers have quit since 2014 – 10 per cent of the total in England and Wales – after a 30 per cent slide in milk prices over the same period', and the Royal Association of British Dairy Farmers ran a survey in 2015 that predicted that 49% of Britain's dairy farmers were scheduled to leave the sector (see http://www.rabdf.co.uk/latest-news/2015/9/7/rabdf-survey-reveals-50-of-producers-set-quit-dairy-farming). Meanwhile, the Lost Pubs Project confirmed on 7 April 2016 that pubs continue to close at the rate of four every day (http://www.closedpubs.co.uk/; see also Christopher Snowdon's Institute of Economic Affairs Briefing 14:08, *Closing Time: Who's Killing the British Pub?* (December 2015), available online at http://www.iea.org.uk/sites/default/files/publications/files/Briefing_Closing%20time_web.pdf.

9 Kingsnorth 2009, p. 7.
10 See Carole Fabricant, *Swift's Landscape*, Baltimore: Johns Hopkins UP, 1982, p. 73.
11 If they ever were, it might be as a background to a religious episode: for example, Pieter Breugel the Elder's *Census at Jerusalem* (1566) – but such depictions were not part of the English tradition; see Margaret Aston, *The Panorama of the Renaissance*, London, Thames & Hudson, 1996, pp. 184–85.
12 John Aikin, *Letters from a Father to his Son, on Various Topics, relative to Literature and the Conduct of Life*, London, 1793, pp. 148–49.
13 Denis E. Cosgrove, 'Landscape and Landschaft', *German Historical Institute Bulletin*, no. 35, 2004, pp. 57–71 (see also Denis E. Cosgrove, *Social Formation and Symbolic Landscape*, London: Croom Helm, 1984, and Denis E. Cosgrove and Stephen Daniels (eds.), *The Iconography of Landscape: Essays on the Symbolic Representation, Design and Use of Past Environments*, Cambridge: CUP, 1989); Neil Evernden, *The Social Creation of Nature*, Baltimore and London: Johns Hopkins UP, 1992, pp. 72–87; John Brinckerhoff Jackson, *Discovering Vernacular Landscape*, New Haven and London: Yale UP, 1984, pp. 3–8; and Marvin W. Mikesell, 'Landscape', in Paul W. English and Robert Mayfield (eds), *Man, Space, and Environment*, New York: Oxford UP, 1972, pp. 9–15; '*Landschaft*' originally meant 'a unit of human occupation' (*OED*).
14 Thomas Blount, *Glossographia; or, A Dictionary interpreting All Such Hard Words, whether Hebrew, Greek or Latin … as are now used in our Refined English Tongue*, London, 1656, fol. Y8ᵛ; Blount's definition seems influenced by the Greco-Latin term '*parergon*', meaning 'accessory': see Simon Schama, *Landscape and Memory*, London: HarperCollins, 1994, p. 10.
15 'An Extract of a Dissertation concerning Pastoral Poetry, written by the Abbot Fraguier', in *The Memoirs of Literature.*

*Containing a Weekly Account of the State of Learning, both at Home and Abroad*, 4 vols., London, 1712–14, I, p. 42 (22 May 1710).
16 William Gilpin, *Observations, Relative Chiefly to Picturesque Beauty, made in the Year 1772, on Several Parts of England; Particularly the Mountains, and Lakes of Cumberland, and Westmoreland*, 2 vols., London, 1786, II, pp. 258–59.
17 Gilpin 1786, II, pp. 43–48; shepherds tending their sheep were permitted (II, p. 261).
18 Humphrey Repton, *Sketches and Hints on Landscape Gardening*, London, 1794, p. 59.
19 Richard Payne Knight, *The Landscape, A Didactic Poem*, London, 1794, p. 32.
20 Wordsworth objected, for example, to whitewashing exteriors, unless 'the glare of whitewash has been subdued by time and enriched by weather-stains' (*Wordsworth's Guide to the Lakes*, 5th edn, ed. Ernest de Selincourt, London: Oxford UP, 1970, p. 84); see Stephen Gill, *Wordsworth and the Victorians*, Oxford: Clarendon Press, 1998, pp. 247–49; see Stephen Hebron, *The Romantics and the British Landscape*, London: British Library, 2006, pp. 135–69.
21 Jeremy Burchardt, *Paradise Lost: Rural Idyll and Social Change since 1800*, London and New York: I.B. Tauris, 2002, pp. 185–86: see Paul Cloke, 'The Countryside as Commodity: New Spaces for Rural Leisure', in Sue Glyptis (ed.), *Leisure and the Environment: Essays in Honour of Professor J.A. Patmore*, London: Belhaven Press, 1993, pp. 53–67.
22 Burchardt suggests that in the twentieth century 'the countryside as an object of consumption rather than as a means of production … has more significantly affected English society' (Burchardt 2002, p. 2; see also p. 204).
23 Burchardt 2002, p. 165.

# ANNA FOX

Rosemary Shirley (RS): What I really like about your approach to making photographic work about rural places is that you have not become a 'landscape photographer'; instead you make work which documents or explores what it is like to live in rural places. Was this a conscious decision for you?

Anna Fox (AF): I have never been interested in being a landscape photographer – a landscape might form part of the narrative of a body of work but I cannot see myself making a whole series of landscapes. I love photographing people (I enjoy the interaction) and I find my way into understanding places and situations through the people. I know that one can find society and humanity reflected in the landscape but for me the interest is in how I can read it through people and their actions and expressions. It feels more immediate to photograph the people and I like that.

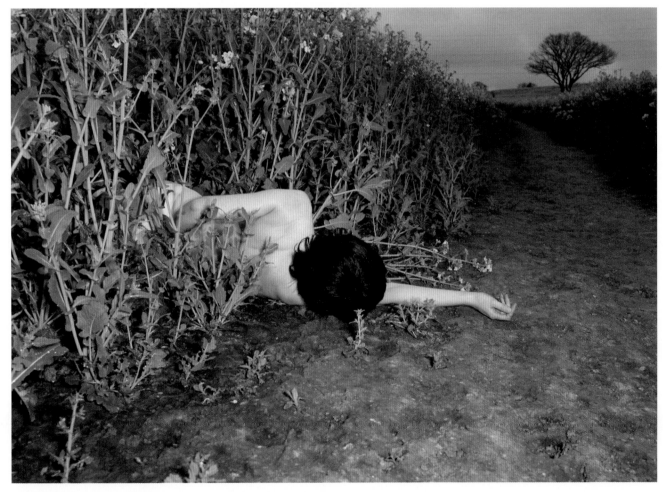

40
**ANNA FOX + ALISON GOLDFRAPP**
*Untitled*, from *Country Girls*, 1999
C-Type colour print, 102 x 142 cm
© The artist, courtesy of The Hyman
Collection, London

**41a–b**
*Back to the Village*: Hampshire
*Village Pram Race*, 2006 and 2004
Matt light jet print archival, 74 x 74 cm
© The artist, courtesy of The Hyman
Collection, London

RS: Your series *Country Girls* features highly stylized scenarios where rural landscapes become locations for violent crimes against women. While on one hand this is shocking, it is also strangely cosy and as familiar as the mainstays of Sunday night TV like *Miss Marple* or *Midsomer Murders*. Why did you decide to explore this theme?

AF: That makes me smile – I mean to think that these situations are cosy is odd, isn't it? And you are right those programmes make it feel like that – and how many times do I think to myself how ludicrous those programmes are? *Country Girls* is a collaboration with Alison Goldfrapp and it is not a series that either of us consider to be 'cosy'. We played with the relationship between glamour and horror (in the styling of the images) and perhaps these could be considered to be part of the tropes of fashion photography and documentary photography all mixed up. Through the use of glamour and colour the viewer is attracted to the image and then (potentially) repelled or attracted further and then confused – the images are likely to leave the viewer feeling uncomfortable, and this is how we both felt about being a young woman in the countryside (we were referring to the time we were in our late teens so the late '70s and early '80s).

I am interested in cracking open everyday myths, in looking behind the scenes and exposing some of the secret stories of the English countryside. Many of these stories have been about women's lives and *Country Girls* is a series that is very much about women's experience in rural England albeit that it also refers to our (Alison's and my) stories and the particular period when we were young women in rural Hampshire. The series also refers to the story of Sweet Fanny Adams, who was violently murdered in Alton, Hampshire, in the early 1900s. The

**42**
*Untitled*, from *The Village*, 1991
C-Type colour print, 49 x 54 cm
© The artist, courtesy of The Hyman
Collection, London

work is deliberately stylized, it is intended to attract the gaze and then repel or confuse it – hopefully this leaves people with an uncomfortable feeling which they may relate back to thinking about women in the countryside. I live in the countryside and I am still uncomfortable walking on my own (with a big dog is OK!).

RS: In *Back to the Village* you record some of the annual customs that take place in the village where you live. Do you think these customs say something about contemporary rural life? Why did you feel it was important to record them?

AF: It's an important question as, yes, I feel the rituals help to describe the nature of village life and that their theatricality allows for certain hidden sides of village life to emerge through the characters in the performance – this is not exactly easy to articulate – I feel like I am using the performances to represent something that lies beneath the surface of what village life generally looks like from the outside. There is something stifling and quite nasty about

village life and the carnivalesque nature of local ritualistic customs seems to expose the darker side of the rural environment – this is what interests me – again, what lies behind the façade? The chocolate box image of the village green is so fake, what is hiding in the wings?

The characters that I photograph are not themselves, they are representing other beings – to some extent the whole of life anywhere is a performance but in a village there is a considerable difference, in that once you have performed a role/a persona you are sort of stuck with it, it is what defines you, and if you do something unexpected in relation to your definition then things can get difficult! As I said – rural life can be stifling.

RS: Sometimes the view of village life portrayed in your photographs feels claustrophobic and confined, for example the images from *The Village* where the viewer is peering through the gaps in hedges or fences, confined by these boundaries but also part of the constant surveillance which seems to be part of

village life. Would you agree? Is this always the case or do other works give a different perspective?

AF: Yes, definitely, and this is what I was trying to convey in that series. Those images are often seen as part of an installation which is mostly inside a small dark (hot and claustrophobic) box which the viewer has to go into to view the massive colour images projected on all walls accompanied by a whispered sound-track of gossip and birds squawking, playing very loud – it was extremely claustrophobic. I felt claustrophobic growing up in an environment just like this, the English village is <u>so</u> conservative I often felt that we all had to hide [who we really were]. Then as I got older I couldn't understand the values of the community at all. Now I am back living there but I live a life mainly outside the village, and this makes it fine – there is now a much broader range of people in the English village but [it is] still nowhere near as diverse as any city – shame, really, as I love the countryside!

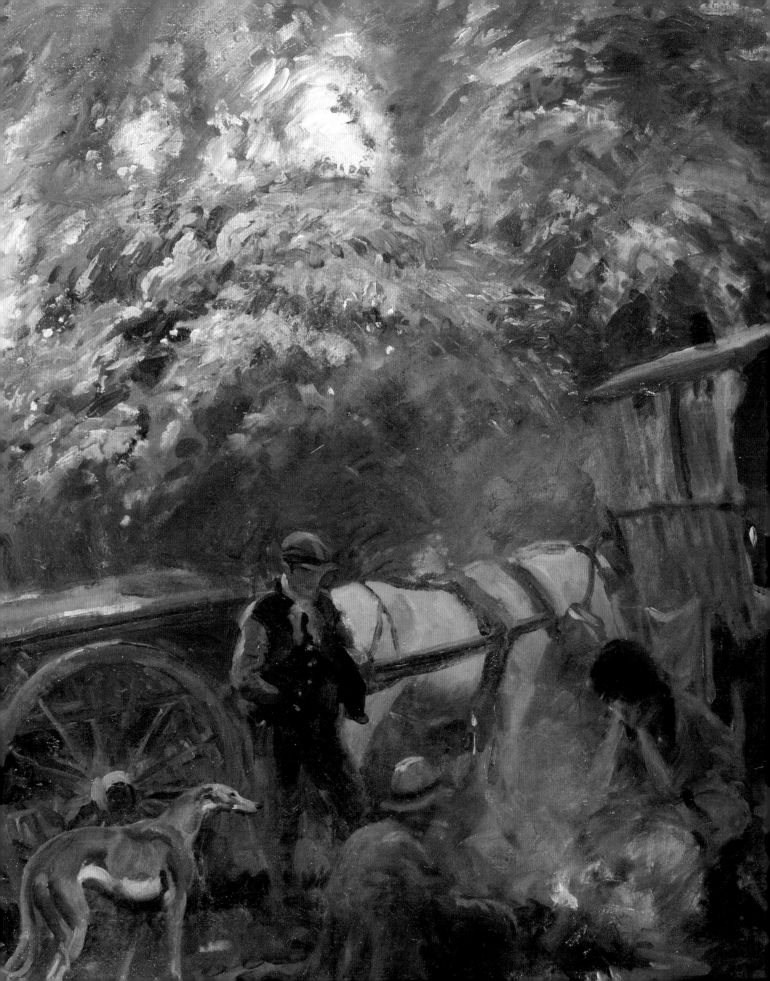

# The Rural Idyll: A Critique

JEREMY BURCHARDT

lthough we might wish to believe otherwise, the lone scholar, sternly aloof from the sway of academic fashion, is a figment of the imagination. Words, phrases and concepts come into and pass out of vogue on the conference circuit and the pages of learned journals just as they do in the world at large. A phrase that has enjoyed considerable academic currency for several decades, and which as yet shows few signs of fading away, is 'the rural idyll'. Yet, although it is very widely used, including by myself in previous work, and has sometimes been employed in an effective and illuminating manner, the term is rarely defined.[1] It is the contention of this essay that it obscures more than it reveals, and would be best abandoned, or at least used in a much more circumscribed manner.

Undoubtedly, the rural idyll has some important advantages as a concept. It is a useful shorthand to describe a congeries of positive attitudes towards, and representations of, rural life and landscapes. It is a succinct phrase that conveys a clear meaning; it indicates how strongly positive attitudes to the countryside can be, and, through the association with the term 'idealizing', it implies also that they bear a doubtful relationship to rural reality, whatever that may be. In the hands of capable critics such as Howard Newby, Martin Wiener, Simon Miller and,

for that matter, Alice Carey in this volume, the notion of a rural idyll can be deployed very effectively to expose the manifold ways in which representations of the countryside have been used to divert attention from, or even deny the existence of, the centuries of poverty, inequality and injustice that have disfigured the history of rural England.[2] However, this polemical utility can come at a high interpretative price.

The most obvious problem is that the concept is too monolithic. It has been used to subsume positive attitudes to the countryside from the time of the ancient Greek writer Theocritus to the present day. Even over much shorter timescales there are often huge contrasts in how the rural is understood and valued, however. Take the example of attitudes to mountains. Many scholars argue that there was a radical transition from 'mountain gloom' to 'mountain glory', in the words of Marjorie Hope Nicolson, between the seventeenth and the late eighteenth centuries. Early modern writers tended to see mountains as barren, dangerous wastelands, hateful in the eyes of God and man – perhaps even the rubbish that was left over after Creation. By the late eighteenth century, mountains had become invested with profound spiritual significance and were central to the systems of meaning developed by many English and German Romantics.[3] Even more fundamentally, scholars such as Donna Landry have argued that the countryside itself was 'invented' during the eighteenth century.[4] The word 'countryside' only became current during the nineteenth century and even 'landscape' only became current in its modern sense in England during the seventeenth century. Both terms reflect ways of seeing and thinking that seem not to have

been available before. When such profound changes have taken place within the last few centuries in the way we understand and value the rural, the utility of an overarching term such as 'rural idyll' that elides these differences must be open to question.

Nor is it only with respect to variance over time that the rural idyll elides deep-seated differences. The same applies with respect to place. Although the archetype context for the rural idyll is England, it has been applied to countries as diverse as France, Japan, Australia, the USA and indeed many others.[5] Yet attitudes to the rural differ greatly between, and sometimes even within, different countries. Whereas the supposed English rural idyll is usually associated with an emphasis on the visual – prospects, views, beauty spots and the like – in France the rural idyll is construed in agricultural terms, based on food production, the soil and peasant self-sufficiency. Japanese constructions of the rural idyll focus on beauty, purity and the ephemeral – flowers, blossom, mountain snow. Scholars who deploy the rural idyll concept in an Australian context are less interested in landscape, agriculture or nature: for them, 'the rural idyll' denotes a leisure-orientated lifestyle and its key coordinates are activities such as water sports, sunbathing and skiing. The US rural idyll is often understood in quasi-political terms – the Jeffersonian tradition of agrarian independence is the core idea here. Small farmers, owning their own property and beholden to no-one, were perceived as the rootstock of American democracy, constituting the ideal, incorruptible voter. Even within a much more limited spatial setting, there can be huge contrasts in what is regarded as estimable or precious in rural landscapes. Consider Lancelot 'Capability' Brown and the natural style of landscape gardening on the one hand and John Clare on the other. Brown cherished huge, sweeping landscapes, in which the eye was often

drawn to a distant vantage point and the scale was epic, the *locus classicus* being Blenheim Palace, with its wide lakes, monumental bridge, massed groups of trees and grand, framed vistas. For Clare, born only ten years after Brown's death, the scale could hardly have been more different. What he loved was the little things of nature, things that a devotee of the natural style would not have considered worthy of notice – tiny insects, grasses, pebbles in a stream, subdued birdsong. Almost the only thing in common between Brown and Clare's attitudes to rural landscape is that both valued it highly – but what they valued it for, and why they did so, differed comprehensively.

The profound variance across time and space of attitudes to the countryside should be enough to call into question the utility of the concept of the rural idyll. But this is not all. The concept is also hopelessly vague (which is what has allowed it to be stretched to apply to so many different contexts). Many of the attitudes that have been taken as exemplifying it are mutually contradictory, or at any rate point in opposite directions. For example, the notion that the countryside is a place of solitude where individuals can go to 'discover themselves' was popular among Romantic writers, at least in theory, although in practice their rural encounters were more often in company.[6] Yet the rural idyll has also often been associated with a belief that the countryside is the place – perhaps even the only surviving place – where authentic community can be found. This is the bedrock of many of Thomas Hardy's novels: one thinks of *Far from the Madding Crowd* and *The Woodlanders*, for example.

The concept of the rural idyll is also too encompassing in social terms. It is strongly associated, as for example in the highly influential work of Martin Wiener, with a high cultural, literary tradition. But it has often been invoked to describe

or explain popular attitudes, values and behaviour. The implication, sometimes explicit and sometimes not, is that the latter were derived from the former. Yet, as Georgina Boyes has argued, the assumption that ordinary people are incapable of creating their own cultural material, forms and traditions is deeply problematic.[7] Even if it is the case – which, as I have noted above, is extremely doubtful – that high cultural attitudes to the countryside can be usefully characterized by the term 'idyll', to assume that the same perceptions and values also defined popular culture is unwarranted.

A further difficulty with the concept is that it is over-intellectualized. Insofar as it is regarded as an explanatory rather than merely descriptive term – and it has most often been invoked by scholars as an explanation, or partial explanation, of major features of modern British history such as the alleged late nineteenth-century 'decline of the industrial spirit' – it assumes that what matters is the 'attitude' people had to the countryside. But attitudes are shallow and variable, the intellectual equivalent of moods. We do not speak of a person's attitude to their family, to religion, to politics or whatever, but about love, faith, political convictions and so forth. This is because we recognize that how someone relates to the important things in their life is not merely a result of cerebral thought processes, but of a much richer, more complex and more multi-dimensional set of relationships, arising from dynamic, ongoing interactions rather than disembodied concepts passively absorbed from some alien site of cultural production. With respect to the countryside, what this implies is that the relevant thing is not 'attitudes' but the totality of all experiences in, of and relating to rural landscapes.

The concept of the rural idyll is also too one-sided. Although some scholars have been at pains to emphasize the countervailing negative stereotype

– Keith Snell and Mark Freeman, for example, have written effectively about the 'Hodge' stereotype of agricultural labourers – there is no equivalent negative term to the rural idyll.[8] The scholarly literature overwhelmingly emphasizes the dominance of positive attitudes to the countryside. But this, to say the least, has not been demonstrated. Whether or not the countryside was viewed positively by most people in any particular place (for example, England) at any particular time (for example, 1914) is in principle an empirical matter. The research, however, to gauge this has simply not been done. There are indications that popular attitudes to the countryside may well, at least at certain times, have been much more nuanced and perhaps even skewed towards the negative than the rural idyll paradigm acknowledges. Tellingly, such straws in the wind are most apparent in studies emanating from disciplinary contexts and research agendas largely uninfluenced by or indifferent to the rural idyll literature. A good example is Littlejohn's participant observation sociological study of the Borders sheep-farming and forestry community of Westrigg. Littlejohn found that residents of the local market town knew very little about Westrigg. Few of them had ever been there and many townspeople looked down on the villagers, regarding them as boorish and uncultured.[9]

Some scholarly accounts do acknowledge, and even highlight, this negative stereotype. But this is only a small step forward. Shoehorning all attitudes to the countryside into an either/or, positive/negative dichotomy is unhelpfully reductive. Even the most extreme cases usually turn out to be more nuanced on closer inspection. Turner's *Ploughing up turnips near Slough*, a glowing rendition of Windsor Castle rising majestically over a misty agrarian landscape, has been read as a coded expression of rural exploitation and revolutionary potential.[10] Wordsworth may, at

**44**
**WILLIAM BLAKE**
Illustrations to Robert Thornton's
*Pastorals of Virgil*, 1821
Wood engravings, each 2.5 x 7.5 cm
© Ashmolean Museum, Oxford

ILLUSTRATIONS OF IMITATION OF ECLOGUE I.

THENOT.

COLINET.

COLINET.

THENOT.

ILLUSTRATIONS OF IMITATION OF ECLOGUE I.

THENOT. To illustrate lines 1, 2.

3, 4, 5, 6.

7, 8, 9.

10.

one time, have thought that 'one impulse from a vernal wood' was worth more than all the books ever written, but he was also the author of perhaps the most celebrated paean of praise to London ever penned.[11] There is as wide a range of attitudes to the countryside, with as many complexities and apparent contradictions, as to any other subject.

The most serious problem arising from the unreflective scholarly over-use of the rural idyll concept, however, is that it is far too dismissive. It lumps all positive views of the countryside together, as if they formed a single cultural entity. Worse, it assumes *a priori* that these views were all idealized or even illusory, and that our task as academics is to debunk them. But this is a very high-handed and, indeed, fundamentally unsound academic procedure. It is at least a possibility that should be considered, and researched, that some of those who valued the countryside may have had good reasons for doing so. 'The enormous condescension of posterity' has, perhaps, rarely been more in evidence than in the case of scholars writing about the rural idyll.[12] There were, undoubtedly, people who held wilfully and one-sidedly positive views about the countryside. But before charging them with this, historians should specify the perceptions that they believe were one-sided and demonstrate that this was indeed the case.

So dominant has the rural idyll framework become that *any* positive view or experience of the countryside tends to be subsumed within it. Such a totalizing approach is implausible and unrealistic and fails to do justice to the complexity of lived human experience. There have, undoubtedly, been many positive aspects of rural life across a range of cultures and time-periods, depending on numerous variables such as class, gender, age, place and specific historical circumstances. However, scholars have

tended to neglect this, preferring to direct their endeavour, for understandable reasons, to debunking perceived bias in the representation of the rural. Some scholars, again often working outside the disciplines of literary studies and history within which the rural idyll concept has been most pervasive, have begun to pay closer attention to the persistence of widespread popular enthusiasm for aspects of the countryside, despite strenuous academic efforts to undermine this. An interesting example is Halfacree's study of social representations of the rural by residents of the countryside. Rather than adopting an *a priori* theoretical perspective, this study deployed an empirical approach, seeking to identify what aspects of the rural settlements in which they lived were valued by rural residents. It turned out that many of these attributes had a real basis in substantive experience: 'an important conclusion of this paper is that we must not overestimate the extent to which residents of rural England are naïve advocates of a mythical rural world ... they are very knowledgeable ... and not just the "cultural dupes" of a hegemonic national ideology'. In this instance, largely positive views of the countryside were informed by real experiences and knowledge, rather than by idealized assumptions uncritically absorbed from the wider culture.[13]

How might we get beyond the limitations and distortions of the rural idyll approach? I would argue for an alternative approach based on making a distinction between cultural representations of the countryside (for example in art or literature) and what people think, feel and believe about it. Recognition of this distinction has, perhaps, been held back by the powerful sway of the so-called 'cultural turn' in the humanities since the 1980s. This, a reaction against the arguably reductive materialism of the previously dominant social history approach, foregrounds the

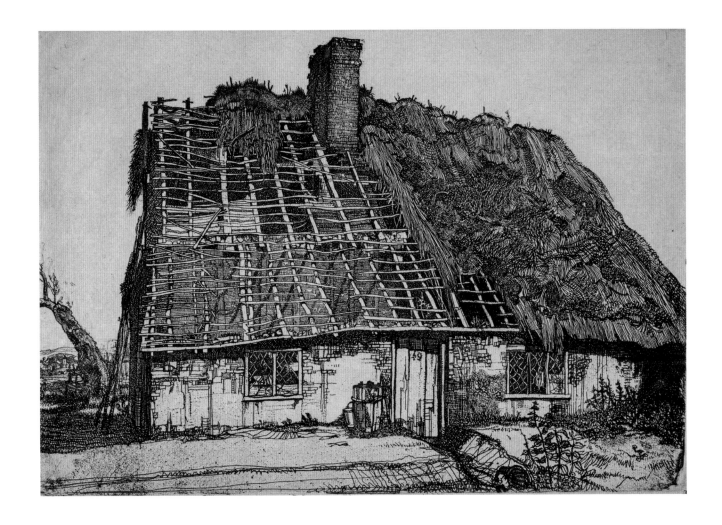

extent to which attitudes and values are 'socially constructed' – that is to say, driven by wider cultural ideas and influences (or 'discourses'). This can very easily lead to a top-down view of history, in which individuals have very little independent agency because their beliefs, loyalties and perhaps even behaviour are largely determined by a matrix of larger intersecting discourses. However, historians are now beginning to question this, positing a greater role for psychological and experiential processes that may affect individuals differentially.[14] With this in mind, it should certainly not be assumed that broad cultural patterns in the representation of the rural correspond or provide a reliable guide to individual responses to rural landscapes. Both are important, but the second should not be reduced to the first.

With respect to representations, it should be recognized that the countryside has always been represented in a wide range of different ways. It would be an improvement on the concept of the rural idyll, or the polarity between rural idyll and its negative opposite, to think of a spectrum of attitudes to rurality, from the highly positive to the highly negative. Even this, however, would be too simplistic because it fails to recognize the co-existence of divergent attitudes within the same individual, at different times and on different occasions, or sometimes even at the same time. Moreover, not all important responses to rural landscapes necessarily carry a distinct positive or negative charge, and this may not be the most important thing even about those that do. The countryside may, for example,

simply be the background to an individual's life: as such, it may affect them in all sorts of ways, without them taking all that much notice of or interest in it. Often it is more important to gauge the nature or character of an individual's relationship to rural landscapes than to assign a reductive positive or negative label to it.

It would, therefore, be preferable to break down the so-called rural idyll – and, for that matter, other attitudes to the countryside, negative or neutral as they may be – into its constituent elements and consider how they relate to each other. The aim would ultimately be to map out the totality of representations of rurality across a given time-period. Within a strictly circumscribed literary context, this was in fact what Raymond Williams sought to do in his path-breaking *The Country and the City*. Williams himself tended to avoid using the phrase 'rural idyll', probably because his commitment to contextualization, comparison and nuance militated against any kind of simplistic reductionism.[15] Williams's work did much to stimulate interest in the place of the rural in representations of England and Englishness but unfortunately the research that ensued rarely replicated the subtlety of his approach or his awareness of how far attitudes arise from specific social circumstances and situations that are constantly in flux.

In addition to a more flexible, sophisticated and comprehensive framework for assessing and analysing representations of rurality, we also need better tools for gauging and interpreting experiences of the rural. While it is possible to trace, albeit with many caveats, some continuities in literary representations of rural landscapes, this is much more difficult with respect to popular experience. Partly the difficulty is one of scale: whereas, at least if we confine ourselves to 'high' culture, there is a somewhat limited number of texts and discourses that we can chart, when it comes to individuals and their experiences of the countryside, this is much less true. Each individual stands at the intersection of so many different economic, social, familial and personal circumstances, pressures and opportunities that it very difficult to map out meaningful generalizations. However, this is no excuse for continuing to purvey bland assumptions based on next to no empirical evidence. Rather, we should acknowledge how little we know about popular engagement with and experience of rural landscapes and make at least some initial attempt to remedy this. A sensible first step would be to sink a series of research 'boreholes' – detailed contextual studies of individuals in relation to rural landscapes, adopting the biographical, 'life-writing' approach that has become increasingly popular with literary scholars and historians in recent years. This depends on abundant, rich source material (such as diaries and letters), so case studies have to be chosen with care and are largely determined by the the availability of suitable archival records. It is also laborious and time-consuming. Nevertheless, it is only by recognizing that we need to research and understand the experiences of non-elite individuals in relation to rural landscapes, in addition to charting a more comprehensive and nuanced map of representations of the countryside, that we will be able to move beyond the limitations and, indeed, distortions of the rural idyll framework – a framework that was highly effective in sustaining polemical critiques in its time, but which has now outlived its usefulness.

NOTES

1 Jeremy Burchardt, *Paradise Lost. Rural Idyll and Social Change, 1800–2000*, London: I.B.Taurus, 2002.

2 Howard Newby, *Green and Pleasant Land? Social Change in Rural England*, Hounslow: Wildwood House, 1979; M.J. Wiener, *English Culture and the Decline of the Industrial Spirit*, Cambridge: CUP, 1981); Simon Miller, 'Urban Dreams and Rural Reality: Land and Landscape in English Culture, 1920–45', *Rural History*, vol. 6, no. 1, 1995, pp. 89–102.

3 Marjorie Hope Nicholson, *Mountain Gloom and Mountain Glory: The Development of the Aesthetics of the Infinite* (Ithaca, NY: Weyerhaeuser Environmental Classics, 1959).

4 Donna Landry, *The Invention of the Countryside: Hunting, Walking and Ecology in English Literature, 1671–1831* (Basingstoke: Palgrave, 2001).

5 Christopher Parsons and Neil Mcwilliam, '"Le Paysan De Paris": Alfred Sensier and the Myth of Rural France', *Oxford Art Journal*, vol. 6, no. 2, 1983, pp. 38–58; Janet Chang, Wen-Yu Su and Chih-Chia Chang, 'The Creative Destruction of Ainu Community in Hokkaido, Japan', *Asia Pacific Journal of Tourism Research*, vol. 16, no. 5, 2011, pp. 505–16; D.J. Walmsley, W.R. Epps and C.J. Duncan, 'Migration to the New South Wales North Coast 1986–1991: Lifestyle Motivated Counterurbanisation', *Geoforum*, vol. 29, no. 1, 1998, pp. 105–18; Andrew Wilson, *The Culture of Nature: North American Landscape from Disney to the Exxon Valdez*, Toronto: Between the Lines, 1991; Michael F. Bunce and Michael Bunce, *The Countryside Ideal: Anglo-American Images of Landscape*, London: Routledge, 1994.

6 As his sister's journal shows, William Wordsworth was wandering with her rather than 'lonely as a cloud' when he made his iconic sighting of daffodils on the shores of Ullswater: Dorothy Wordsworth, *Journals of Dorothy Wordsworth*, Oxford: Oxford World's Classics, 1980, p. 109 (15 April 1802).

7 Georgina Boyes, *The Imagined Village: Culture, Ideology and the English Folk Revival*, New York: Routledge, 1993).

8 Keith D.M. Snell, *Annals of the Labouring Poor: Social Change and Agrarian England, 1660–1900*, Cambridge: CUP, 1985.

9 J. Littlejohn, *Westrigg: The Sociology of a Cheviot Village*, London: Routledge & Kegan Paul, 1963.

10 Michele L. Miller, 'J.M.W. Turner's Ploughing up Turnips, near Slough: The Cultivation of Cultural Dissent', *The Art Bulletin*, vol. 77, no. 4, 1995, pp. 572–83.

11 William Wordsworth, 'The Tables Turned. An Evening Scene, on the same Subject' and 'Lines Composed upon Westminster Bridge, September 3, 1802'.

12 Edward Palmer Thompson, *The Making of the English Working Class*, London: Pelican Books, 1980, p. 12.

13 Keith H. Halfacree, 'Talking About Rurality: Social Representations of the Rural as Expressed by Residents of Six English Parishes', *Journal of Rural Studies*, vol. 11, no. 1, 1995, pp. 1–20 at p. 19.

14 M. Roper, 'Slipping out of View: Subjectivity and Emotion in Gender History', *History Workshop Journal*, vol. 59, Spring 2005, pp. 57–72.

15 Raymond Williams, *The Country and the City*, London: Chatto & Windus, 1973.

# HILARY JACK

**Rosemary Shirley (RS): Your work often feels quite apocalyptic, including images of the landscape being exploited, polluted and ultimately destroyed. However, these global hyper-narratives are often combined with mundane everyday objects like plastic bags and postcards. Is this deliberate – can you say more about it?**

Hilary Jack (HJ): We're living in very strange and uneasy times. Contemporary society seems trapped between the desire for mass consumption and the quest for infinite pleasure, while the fear of global catastrophe, environmental disaster and the threat of terrorism hangs over our heads. The everyday found objects I choose to work with are often 'victims' of a form of their own apocalyptic circumstances, such as built-in obsolescence, or becoming lost, or discarded. These unexceptional objects can sometimes tell us more about the way we live our lives than the headlines in a constant stream of daily news.

**RS: Could you tell me about the origins of your work *Turquoise Bag in a Tree*?**

HJ: In the winter of 2003, I noticed a plain turquoise plastic carrier-bag snagged in the branches of a tree near my studio in Manchester. The image stuck with me. I photographed it, eventually building up a large collection of similar images and building a website to house them at www.turquoisebaginatree.co.uk. The images had a viral effect and I started to receive pictures of turquoise carrier bags snagged in trees from all over the UK and as far afield as the Czech Republic, Africa and the USA.

Inseparably linked to consumer society, plastic carrier-bags are often used just once and discarded as waste, a symbol of our ability to despoil our planet. I see the discarded plastic bag as an 'object of doom', with the capacity to choke and suffocate,

causing all manner of environmental problems, its toxic remains poisoning the soil for thousands of years to come. The turquoise bag continues to be a motif in my work.

In 2015, after years of contentious debate, the government introduced the 5p bag tax on all plastic bags sold in supermarkets and large stores. Single-colour bags, used by small retailers, are exempt from the tax, so the turquoise bag lives on. I decided to cast a plastic bag in bronze, and paint it with turquoise enamel and suspend it from the ceiling of the gallery, as if snagged in the branches of a tree. My use of bronze references historic and memorial public art and infuses the object with gravitas and embedded monetary value. The bronze bag weighs 12 kg and hangs above our heads, in

**46**
*Turquoise Bag in a Tree*, 2016 (detail)
Found tree trunk, with cast bronze plastic carrier bag, 700 x 400 cm
© The artist

judgement, like the sword of Damocles. The tree it hangs from is dead – a prophecy of environmental crises not to be disregarded, a weighty *memento mori* that is difficult to ignore.

**RS: In your piece *Souvenir* viewers peer through a hole in the wall to see images of the landscape on a slide projector. It's really interesting how this piece**

problematizes the act of looking at the landscape, especially when 'the view' is so often a primary way of engaging with rural places. Is this something you were thinking about?

Walking through woodland I found a knot of wood lying on the forest floor that vividly resembled an eye. Once I'd picked it up there was the irresistible temptation to hold the object close to my own eye and peer through it. This immediately presented a cropped version of the landscape before me and created an intense feeling of intimacy and a sense of invisibility – like looking through a secret peephole. As I turned my head from left to right the wooden eye offered up different cropped versions of the wooded landscape, alighting on a random sequence of images – a scenic pathway, the skull of a dead animal, a misty canopy of green leaves. It reminded me of one of those novelty souvenir view-finders in the shape of a television where you click a button and a new image is presented of the place you've visited.

The experience made me consider how we are presented with 'the view' in the past and the present day. Photographs intended as tourist postcards offer the viewer a cropped and perfect composition of a particular aspect of the landscape. Anything regarded as unseemly or un-picturesque is cropped out. This gives the illusion of control over the subject, control over nature, and presents the landscape as unchanging and permanent. I often experience a huge sense of disappointment when visiting a famous tourist site I've previously only experienced via images – for example I'd naively expected Niagara Falls to be surrounded by lush countryside and was horrified to find it surrounded by burger joints, shopping malls, and neon signs advertising cheap motels.

Today we view and receive thousands of images in an endless stream – filtered, photoshopped, unsolicited, and sometimes undesirable – beamed directly to us via our smart phones in our pockets. They often offer us a fake version of the world, a hyper-normalized and edited view of the way we live our lives. In times of difficulty and uncertainty the temptation is to retreat into the past or into a fake vision of our own lives.

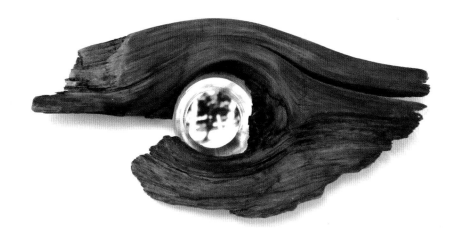

**47**
*Souvenir*, 2012
Found knot of wood and slide projection, 20 x 10cm
© The artist

The future seems bleak or too confusing, so we settle into nostalgia and disengage from what is too difficult for us to address, and indulge in a more simplistic way of life. Perhaps this explains our societal obsessions with England's rural past – cupcakes, farmers' markets and historically inaccurate costume dramas like Downton Abbey. The title *Souvenir* indicates a time shift, that the images that the viewer is seeing are part of the past, as if the piece is a way of remembering the landscape from a post-landscape future.

**RS: Many of your pieces seem to oscillate between the future and the past. Can you say more about how these time slips function in your work?**

Trinkets and photographs transport us back to a particular moment, triggering memories of our lived experience – a reminder of a place, event or person. The title *Souvenir* comes from the French verb 'to remember'. The component parts of the installation are an analogue slide projector, sixty 35 ml slides depicting holiday snaps of British landscapes in the 1960s, and more recent archive images of rural activities involving industrial processes. Some of the images are sublime scenes of mountains and lakes, while other images are less comforting. The wooden eye functions as a 'seer', allowing glimpses into the past of vistas perhaps now lost and people perhaps no longer with us. The steady

comforting click and whir of the projector as slides drop into the view finder suggests the passing of time, a metronomic beat, marching us into the future.

In my wall-based piece, *The Late Great Planet Earth*, the title suggests an elegiac narrative, a lost and exemplary world, while the descending collage of postcards speaks of an extended idyllic landscape, and a pre-internet time gone by. The postcards have been sent through the post, bearing a second-class stamp and a handwritten message conveying good wishes and describing innocent days in chilly British seaside resorts. They seem quaint and slow-paced in contrast to today's electronic instant messaging and posed and instagrammed days out and holidays abroad.

The postcards remind us of what the earth looked like in its natural state before the dialogue of climate change began.

My intention is that the work encourages the viewer to contemplate our place in the world, the earth under our feet, and consider what the future holds for us in this time of the new geological era of the Anthropocene.

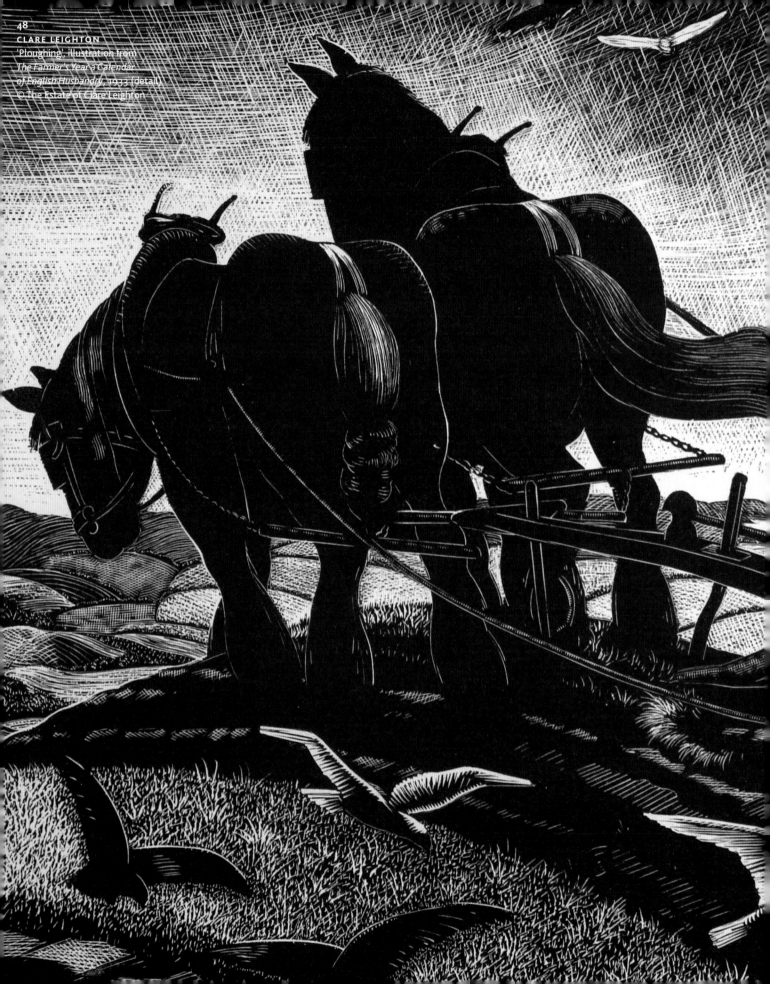

# This Land

ALICE CAREY

Approaching via a litter-blown forecourt or concrete stairwell, smartphone pulsing with an unfamiliar city postcode, exhibition visitors may or may not consciously register the 'post-industrial' nature of an old warehouse or former factory venue. The appropriation of sites of lost industry, where art world fantasies of fame and fortune play overture to gentrification, is a well-rehearsed theme. But post-industrial city spaces have their country cousins – I first encountered the term 'post-agriculture' over a decade ago – and these too play host to activity that can feel worlds away from the goods and services formerly produced on site.[1] As a context for cultural display and consumption, the farm contains and confers a particular value that resonates down the centuries. Exploration of the farm's position at the heart of English cultural imagination reveals how the objects and aesthetics of art and farming mediate the power and social relations that structure the evergreen myth of the rural idyll.

In the wake of modern industrialization, the farm – the original site of labour and economics – was superseded by the factory as the defining metaphor for human toil.[23] Charlie Chaplin's *Modern Times* offers a neat visual analogue: the film's opening overhead shot of sheep being herded through a crush dissolves into a similar view on factory workers streaming out of the subway and into work. By the twentieth century, people had largely disappeared from the farm, and so indeed it all but disappeared from us, allowing an increasingly romanticized view to spring up in the gap of expanding naiveté.

With less than 1% of the UK population now employed in agriculture, the depopulation of our farms has led to the contextual untethering of the signs and symbols of farming. Generalized and circulating, they produce a system of cultural codes that direct and even obscure popular understanding of agriculture.[4] Hardly any of us derive a livelihood from agricultural production, but instead the abstracted farm permeates our consumer consciousness, popping up in all manner of situations from interior decoration to children's books, not to mention (imagined) sartorial modes.[5] Adopted as an expression of legitimizing earthiness by Queen Victoria, the country ethic of the Royal Family's tweedy 'Balmorality' is an enduring style, visible to this day in the iconic form of our regularly gum-booted Queen.[6] Back amongst the hoi polloi, the all-weather dandyism of the soft-handed Barbour-toting 'Shoreditch farmer' is just the latest plebeian iteration of this peculiarly English type of power dressing.

The specific performance of royal rural rootedness reflects a wider tradition of paternalism and power that forms the ideological bedrock of England's farming landscapes. If individual nations have at one time or another laid claim to distinct types of natural ideal, from the sylvan projects associated with German nationalism to the frontier wilderness of North America's manifest destiny, then the gentle undulations of post-Enclosure farming landscape represents a fantasy of Englishness. Propaganda

**49**
**ENGLISH SCHOOL**
*A Farmer and his Prize Heifer*, c.1844 (detail)
Oil on canvas, 80 x 90 cm
© Compton Verney

material from both First and Second World Wars
mobilized this ideal to inspire the patriotism
required to save the nation it stood for (see fig. 50).[7]
Combinations of the good shepherd, farmer, father
and soldier figured the vigorous paternalism
underlying both the landscape and the call to arms;
the topographical and nationalistic meanings of the
word 'country' collapsed into one another then
as now.

English art history is rich with an iconography
of rural life conceived as radiating from the farm,
or rather the private estate – wellspring of the local
economy and life-blood of the wider national project
of international trade and commerce that developed
with empire. The period between the late eighteenth
and early nineteenth centuries, popularly understood
as 'the Agricultural Revolution' in England, is one
in which images of farming indexed the national
situation. As farming came to the fore, George Stubbs's
*The Reapers* (1783; fig. 51) marked a shift in taste away
from classical pastoral scenes towards representations
of contemporary agricultural labourers, albeit
fashionably dressed in excessively clean clothes.
After the Napoleonic Wars productive land-use went
into decline and the countryside erupted into unrest
and violence. Ongoing upheaval by Enclosure Acts
and their brutal disenfranchisement of the agrarian
labourer, the Poor Law, the Corn Laws, harsh winters
and dreadful harvests, recession, depression, agitation,
anti-industrial protest and vagrancy rendered the
farming landscape less convincing as an image of
timelessness and ease, stimulating a taste for Samuel
Palmer's escapist visions, such as *The Early Ploughman*
(1860–62; fig. 52), or John Linnel's gentle *Shepherd
boy playing a flute* (1831). From the latter half of the
nineteenth century, the repeal of the Corn Laws and
a more optimistic farming mood was reflected in
the popularity of idyllic harvest scenes such as John

Frederick Herring Sr's *Harvest* (1857), although
a growing consciousness around rural conditions
and the patronage of newly rich non-aristocrats
also produced a move towards social realism.
As the urban situation continued to expand and
evolve according to modernizing industrial forces,
the agricultural landscape in the nineteenth century
became increasingly invested with all sorts of moral
and emotional significance for a public grown distant
from the realities of the land-based economy –
a situation we can recognize today.

Agricultural themes signifying national prosperity
and stability were historically linked to the patronage
of the land-owning class, whose tastes were formed
in the 'pastoral'. This classical mode had its basis in
the third-century BCE *Idylls* of the poet Theocritus,
who provided inspiration for the Roman poet
Virgil's *Eclogues* some two hundred years later. Such
works came to seem to represent a timeless world
of leisure and natural abundance where shepherds
were free to pursue their twin concerns of love and
poetry away from the vicissitudes of city life. This
unlocated land held sway over European conceptions,
expectations and representations of the ideal life from
Renaissance times. It found expression in the trope
of the ideally empty landscape view as a stage for the
construction and performance of divine, or at least
noble, identities.[8]

Diligence and worldly care were characteristics
conspicuously absent in the classical pastoral hero,
making him a perfect model for aristocratic self-
fashioning. The toil of work was the curse of fallen
man, figured in the rural labourer and, to an extent,
the merchant – both of whom play their part in
modern conceptions of the farmer. In the *Georgics*,
however, a poem in four books written after the
*Eclogues,* Virgil developed his vision of rustic life
to permit and even valorize a noble confrontation

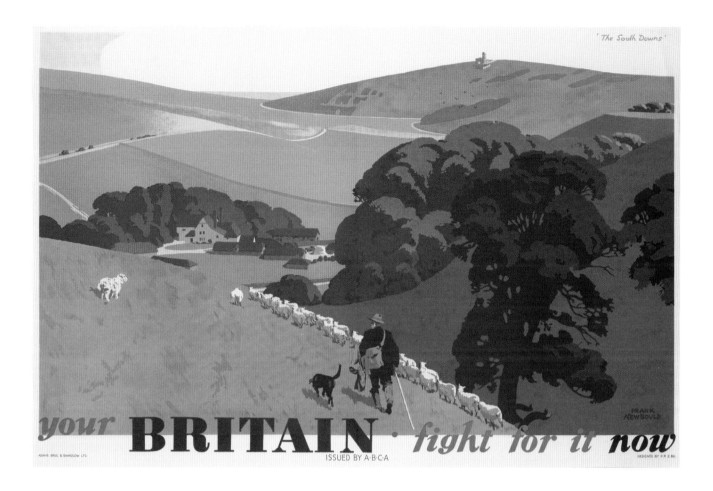

'The South Downs'

*your* **BRITAIN** · *fight for it now*

ISSUED BY A·B·C·A

with the natural world. Time and decay intruded on the idyll, calling for empiricism and skill if progress was to be made. No longer a simple retreat from the cares of courtly life, the idyll was complicated by economics and implicated in a wider political project, linking the family, the farm and the nation. Ideological imperative underpins the didacticism of the *Georgics*, with their famous instructions on bee-keeping, amongst other prescriptions. The publication of John Dryden's English translation of Virgil in 1697 marked a flowering of contemporary poetry that similarly elaborated themes of descriptive utility. Reflecting and elevating the growing productivism of the age, the resulting ideal held particular appeal to a landed elite deeply invested in an unchanging social order of the countryside, which nonetheless presented opportunity for conspicuous displays of patriotism and progress via rapidly evolving farming

technologies. Thomas Gainsborough's famous portrait of *Mr and Mrs Andrews* (1748–49) depicts an agricultural view in keeping with the times. No workers trouble the cultivated scene, but new technology is figured in the beautifully straight lines of the stubble – evidence of a seed drill – with its attendant sheaves of golden corn: Mr Andrews is a man of progress. In this painting the farm is displayed as an object of capital, site of innovation and marker of social standing – the perfect backdrop for a society portrait.

Classically framed and idyllically fashioned, aristocratic visions secured at least a partial view of the farm within the English art historical canon. But the overwhelming taste for conspicuously 'emptied' or stage-managed scenes finds its counterpart in an alternative, lustily populated tradition, one loaded with meaning and currency as any high-falutin' vista.

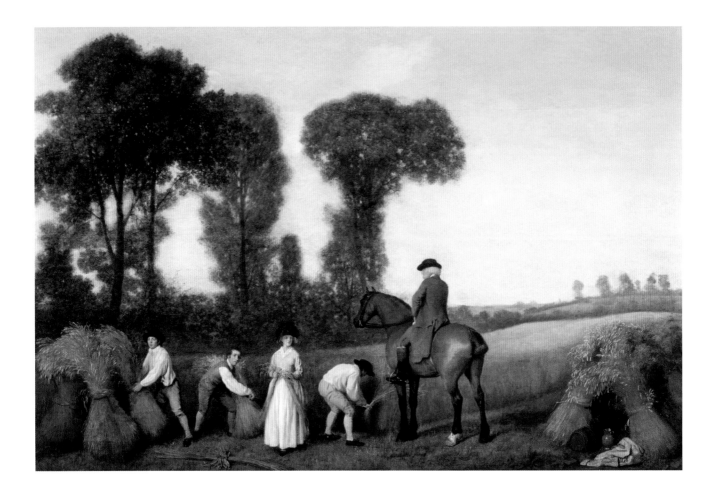

Despite a history of disregard for what has often been sidelined as a folkish curiosity, the genre of livestock painting reproduces the nationalistic myths and cultural modes I have outlined, and more besides. This lively visual culture rode roughshod over the boundaries of classical elitism, accommodating audiences well beyond the manor house, whose walls it nonetheless furnished with images to flatter a noble gaze. The prominence gained by livestock painting during the eighteenth and nineteenth centuries represents a uniquely generative moment between art and farming, and offers another angle on the cultural construction of the farming ideal.

Animal portraiture was originally connected to the sporting traditions of the nobility, not to explicitly commercial agricultural concerns. But, as the landed gentry shifted their country pursuits from the pleasures of the chase to more productivist interests,

the craze took off for images of prize livestock. A diversity of domesticated animals was depicted – from farmyard cats to historic pig breeds – but cattle embodied particular appeal; their obvious connection to the archetypal Englishman 'John Bull' produced a pleasing cultural expression of the popular fervour around farming progress as a driver of national prosperity.[9] Amidst the technological advances of the age, innovative breeding techniques coupled with a widespread availability of new foodstuffs including fodder crops and oil cake greatly enhanced farmers' ability to convert land – via the animal, breeding and deadweight potential – into gold.

The earliest dated cattle portrait is a print of *The Blackwell Ox*, produced in 1780 by engraver John Bailey after a painting, now lost, by George Cuitt. The portrait depicted a particular beast rather than general type of this unimproved old Teeswater breed,

and the work records the animal's breeding, history and vital statistics. The work was thus a functioning artefact that could be used to compare specimens within a breed – testament to the new, scientific approach to animal representation as well as animal breeding. Cuitt had travelled in Italy before returning to establish a flourishing practice in Northumberland as a painter of topographical landscapes and country estates, and it was perhaps his reputation for accurate detail that first inspired breeder Christopher Hill to commission him.[10] Bailey's engraving certainly captures the impressive bulk of the beast, along with its finely wrought curling horns and delicate hooves, all foregrounded in profile against a distant landscape. The artwork is unusual for portraying the animal with its head down, grazing – although it is interesting to note that George Stubbs used a similar composition for his one and only cattle portrait, *The Lincolnshire Ox* (1791). Typically, early cattle artists adopted the established iconography of horse portraiture, with beasts presented in profile to show off their conformation, viewed from a low vantage point against a faraway prospect to emphasize their size. Desirable traits were accentuated – small heads, short legs, long straight backs and wide hindquarters (where the most valuable cuts were located). Breeders encouraged artists to stress the grandeur of their beasts, and were often themselves included in the works, also in profile and diminutively positioned to accentuate the extraordinary scale of their animals, deriving great status from the scene overall. Some farmer patrons were more concerned with size than accuracy in the images they commissioned, a preference borne out in the oeuvre of the prolific Victorian artist Thomas Sidney 'Cow' Cooper, choc with beasts of charm and preposterous heft. The artist Thomas Bewick was less accommodating of clients' promotional priorities, and reportedly once lost a commission over his commitment to reality.

Selective breeding was not an entirely new phenomenon in the late eighteenth century, but one that advanced with the regime of Enclosure, as the *ad hoc* coupling of animals on shared land gave way to a more systematic approach that developed animals according to their productive function, in line with the capitalistic logic of modern agriculture. One man forever linked to the development of English livestock was the farmer Robert Bakewell, who refined and promoted 'in-and-in' breeding techniques to fix and develop desirable traits for specialized breeds.[11] His work established the crucial distinction between spectacular 'fat' animals and 'improved' breeds, scientifically linking pedigree and conformation to produce a method that, by the 1790s, had reached huge audiences. With the majority of the population unable to read, paintings and prints played a key role in promoting new techniques, impressive specimens, and the reputations of the men involved. When the famous Durham Ox was first exhibited in 1802, over 2,000 prints featuring the animal's portrait – one of five to be made in its lifetime – were sold that year alone. An emergent agricultural class, rich off the back of Bakewell's instructions, commissioned and displayed artwork that reflected and promoted the animal objects of their farming success. The view of livestock paintings as 'naive' is a judgement couched in academic expectations of development within a genre, but such a linear conception misses the extraordinary richness and diversity of a tradition encompassing sideshow prints and decorative crockery, pub signs, front parlour arrangements and masterful paintings held in royal and national collections – all developed against a dynamic backdrop of cutting-edge experiment and competition.

By 1803, decades before the Royal Agricultural Society of England received its royal charter in 1840, noble agricultural 'improvers' like Thomas Coke, later Lord Leicester, had variously clubbed together to form at least 32 local agricultural societies. These promoted new techniques and encouraged breeds and practices hitherto unknown in their localities, all with their own shows including classes for the exhibition and judging of livestock. The significance of a model of progress based on genetic inheritance was not lost on aristocratic farmers. What is more, the era of breeding technology chimed with a moment of patriotism brought on by the onset of the Napoleonic wars. With danger figured in the threat from abroad, the tradition of patrimony upheld the Georgic conception of family, farm and nation.[12] Selectively bred animals and their images were ideal objects to mediate this powerful ideology, reinforcing the power and position of elite fanciers even whilst appropriating the rhetoric of utility in service of the wider patriotic project.[13]

The first official herd book was established in 1822, tracing Shorthorn lineage back to animals bred by the acclaimed Collings brothers in the 1780s. Modelled on the Stud Book, established three decades earlier to record thoroughbred lineage, the Herd Book was luxuriously printed and bound, with large type on heavy paper, recording the colour, date of birth, owner, breeder and ancestral genealogy of each individual cow and bull, listed by name. Historians have observed that it also bore a remarkable similarity to that handbook of aristocratic pedigree, Debretts Peerage.[14] Naturally, titled livestock enthusiasts espoused 'purity' and bloodlines as the basis of good breeding practice, promoting in-and-in selection even to the detriment of herd characteristics. Gentleman farmer Thomas Bates was so invested in his herd's superior pedigree that he eschewed the official Herd Book for his own meticulous record-keeping, and

recycled the titled names of his animals to mimic the nomenclature of royal succession. A painting by Henry Stafford depicts one of Thomas Bates's elite shorthorns, a dainty-hooved hulk named *The Duke of Northumberland* (1897).

Noble livestock breeding involved pageantry, prizes, press, wagers and royal patronage in an economy that was worlds away from the practical innovations of Bakewell and his yeomen disciples. Its iconic beasts were asset-class objects of intrinsic desirability; they embodied conspicuous consumption, auctioned and admired in an economy parallel to the extraordinary artworks they inspired. This extravagant contortion of utility to the service of aesthetics and privilege echoes down the centuries, from the eighteenth-century gardening fashion of the 'ornamental farm,' which found its most notorious iteration across the Channel in Marie-Antoinette's Petit Hameau, to the Georgic ideals of the Agricultural Revolution, arriving at its ultimately didactic posture in the Victorian 'model farm'. The nineteenth-century agricultural engineer George Andrews articulated centuries of common wisdom in a plain critique of these model farms, which ordinary farmers associated with 'the practices of those gentlemen, who, having pockets which overflow with wealth from other sources … carry on their agricultural operation regardless of the great question whether it will pay or not'.[15]

Criticism of agricultural activity that falls outside profitable production remains a bitter little tributary of the mainstream farming conversation. The typical affluent 'hobby farmer' of today has amassed wealth through other means, following the old adage that if you want to want to make a small fortune in farming you had better start off with a large one. Being motivated by personal interests, social status, reduction of tax liability perhaps but not direct profit – and seduced by the mythic farming ideal –

**52**
**SAMUEL PALMER**
*The Early Ploughman (The Morning*
*Spread Upon the Mountains)*, 1860–62
Etching, 13.5 x 19.5 cm
© The New Art Gallery Walsall

hobby farmers are the natural heirs to the farming aristocracy of yore, similarly out of step with the concerns of common farmers. But where the aesthetic and pleasurable indulgence of farming was formerly the preserve of an historic patron class, the tax-paying public is now collectively implicated in a subsidy regime that underwrites the agricultural production of public 'goods' and meaning besides food and fibre, with schemes to encourage diversification, stewardship and cultural regeneration.[16] Barns, hedgerows, ditches and ponds – all of which can leverage public funding – still order the farming landscape, indexing patterns of labour, ownership and investment, but their function

can be understood as utilitarian or poetic – or both – depending on your point of view.[17]

These post-productivist influences inform the notion of 'post-agricultural,' being part of a wider problem of changing farming economics and the viability of small- and medium-scale 'family' farms. With half of Britain's dairy farmers going out of business between 2002 and 2015, many farms – like their equivalent spaces in the former heavy industries – have become available for other activity.[18] Durslade Farm in the Somerset town of Bruton was in a dilapidated condition when art dealers Hauser and Wirth bought it in 2012. Developed into a gallery and

opened two years later, it is now a destination for cultural consumption in the form of contemporary art exhibitions, engagement activity and locally produced organic fare. Presenting asset-class art objects in a setting of rustic elegance, with a stated ambition of farm-building stewardship and preservation, this transformation offers a pleasing succession to the history of the plot: the buildings were originally constructed by the Berkeley family in the 1870s as a model farm. The Albion Barn, another private gallery developed in the nearby Cotswolds some years before out of a combination of old farm buildings and new architecture, adopts a similarly restrained yet recognisably rural vernacular for the presentation of blue-chip artworks. Switched from sites of production to consumption, both venues remain circumscribed by enduring hierarchies of access and privilege. These spaces aestheticize and reproduce the social order, their charm and appeal founded in the established farming mythology.

Down the road in Somerset, an altogether more dystopian rurality is at play. Working out of semi-derelict agricultural buildings in Yeovil, Hacker Farm are an artist duo that adapt salvaged materials including milk churns and birdhouses to create analogue electronic instruments, DIY speakers, circuit-bent toys and self-built synthesizers. They describe

their work as 'broken music for a broken Britain' and writing in *The Guardian*, Charlotte Higgins concurs: 'harsh, mechanized and poverty-stricken, forgotten in an era that tends to concentrate on urban deprivation … the rhythm tracks clank and whirr like rusting machinery'.[19]

Whilst this 'farm punk' cultural expression speaks to an alternative tradition of rural non-conformity to rival any English pastoral, the idea of the countryside as the impossible realm of a just vanished 'Golden Age' is one that has retained its power over the centuries, thanks to its capacity for innumerable interpretations. From the Golden Age of the landed nobility whose selective view of their farmed estates enabled them to ignore the iniquities of social relations in favour of a vision of nature's ease and abundance, to the Golden Age of small-scale owner-occupiers, the mythologized 'organic' community of the past who prospered before institutions of government and powerful commercial interests took hold, to the radical notion of a Golden Age free from the tyranny of social hierarchy and inequalities, a 'communized rural idyll' that has inspired rural utopian movements from Shakers to hippies – these models negotiate a powerful zone of English self-imagining as culturally formed ideas about the working landscape come full circle and shape it in their own image.[20]

NOTES

1 Ian Hunter, *A Cultural Strategy for Rural England: Investing in Rural Community Creativity and Cultural Capital* (15 February 2006); http://www.littoral.org.uk/HTML01/pdf/RCstrategyDCMS_Paper.pdf.

2 'The greatest event of the twentieth century incontestably remains the disappearance of agricultural activity from the helm of human life in general and of individual cultures': Michel Serres, *The Natural Contract*, Michigan, 1995, p. 28.

3 By 1850 only 22% of the British workforce was in agriculture – the smallest national proportion recorded at that time across Europe.

4 Employment in Agriculture: http://data.worldbank.org/indicator/SL.AGR.EMPL.ZS (accessed 6 December 2016).

5 Farms are an enduring pedagogical tool, featuring in the books, games, songs and objects of childhood, introducing concepts ranging from animal speciation to the work ethic. For many of us, our early years afford our active engagement with the idea of the farm: the naive sentimentality many of us feel towards farms is culturally and socially encoded from the get-go.

6 J.R. Short, *Imagined Country. Society, Culture and the Environment* London: Routledge, 1991, pp. 74–75. Short's inventive term encapsulates the royal family's enthusiastic adoption of the sentimentalizing myth of Highland Scotland in the nineteenth century,

representing, in condensed form, the wider creation of the British countryside.

7 Proving the all-pervading power of the generalized idyll over specific facts of place or experience, the posters owed more to the allegorical visions of Samuel Palmer or historic scenes of John Constable than any realities of agricultural production.

8 Frank Kermode, 'Nature versus Art,' (1952), in B. Loughrey (ed.) *The Pastoral Mode: A casebook*, London: Macmillan, 1984, p. 93.

9 John Bull was the creation of Scotsman John Arbuthnot, Queen Anne's physician and friend of Jonathan Swift and Alexander Pope. The enduring character first appeared in Arbuthnot's 1712 political allegory *The History of John Bull*. With his bovine character and love of beef, English everyman John Bull was beloved of late eighteenth-century caricaturists, including James Gilroy, and is a recognizable archetype to this day.

10 He went on to produce numerous livestock paintings, including the famous Ketton or Durham Ox of around 1801.

11 'In-and-in' is the method of breeding repeatedly within the same or closely related stocks (the link to nobility is hard to miss) in order to eliminate or intensify chosen traits. Bakewell's breeding techniques were part of a wider project of agricultural experimentation and innovation carried out at Dishley Grange, his Loughborough farm.

12 David Lowenthal, 'British National

Identity and The English Landscape', in *Rural Studies*, vol. 2, no. 2, 1991, p. 206.

13 Harriet Ritvo, *The Animal Estate*, Cambridge, Mass.: Harvard UP, 1987, p. 79.

14 First published in 1769.

15 G.H. Andrews, *Agricultural Engineering, I, Buildings* (London: John Weale, 1852), p. 7.

16 The last few decades has seen CAP move towards 'stewardship' of heritage and environmentalism; landscape is publicly underwritten as a site of common goods, even as it is defined according to capital and private property. With the UK now out of the EU, the nation's farmers face an uncertain future in terms of the subsidy regime. Despite the anti-European rhetoric often heard in farming communities, the NFU lobbied to 'remain' in the referendum; it knew which way its members' bread was buttered.

17 The future shape of UK farming subsidy, following the Brexit vote, remains to be seen.

18 'RABDF survey reveals 50% of producers set to quit dairy farming' (7 September 2015); http://www.rabdf.co.uk/latest-news/2015/9/7/rabdf-survey-reveals-50-of-producers-set-quit-dairy-farming.

19 'Art in the countryside: why more and more UK creatives are leaving the city' (26 August 2013); https://www.theguardian.com/artanddesign/2013/aug/26/art-countryside-uk-creatives.

20 Short 1991, p. 32.

# INTERVIEW

# SIGRID HOLMWOOD

**Rosemary Shirley (RS): The idea of the peasant painter in art history usually relates to nineteenth-century artists who visited or lived in rural places and produced paintings of the 'peasants' they encountered. The resulting artworks were often created for an urban middle-class art market. The peasant painter is a central character in your work but you challenge this established understanding of the term. Can you tell me more about this?**

Sigrid Holmwood (SH): I trace the idea of 'peasant-painting' within Western art history back further, to the sixteenth century and the origins of modernity, in particular to Antwerp and the birth of the art market. Prior to this period the main patrons of art had been the aristocracy and the Church, and artists worked on commission with biblical or mythological themes. With the beginnings of colonialism, Antwerp, then part of the Spanish empire, became a centre of global trade and was the site of what some consider to be the world's first stock market, the *bourse*. The burgeoning merchant class became the new patrons of art, and with them came an explosion of genres – still life, landscapes and, of course, peasant paintings, such as those by Bruegel.

It has been argued by many art historians that these early images of peasants, especially the more bawdy prints, served to construct the urban middle-class sense of self. Peasants were often depicted at festivals or weddings – drinking, eating, dancing, snogging and, in the case of the prints, vomiting and evacuating their bowels. Shown in this way, the peasants represented everything that the middle class urbanite was not – uncouth, backward, prone to bodily excess and closer to nature; therefore some historians have interpreted these images as holding up the peasants for moral approbation. However, I am more inclined to agree with those art historians who see these images in a more nuanced way.

At this time, there was not such a cultural separation between the urban and the rural, and many city dwellers travelled to the villages to partake in these festivals, known as a *kermis*. It is likely that some viewers would have seen these images as comic rather than moralizing, laughing *with* the peasants rather than *at* them. The sixteenth century was a time of great social change with the Reformation, colonial expansion and the beginnings of capitalism. These changes were affecting peasant life; the Lutherans attempted to ban the peasant festivals while landlords were curtailing common rights. I suspect that some of the sixteenth-century images of peasants had a more political tone than might at first appear: certainly Brueghel's engraving *Everyman* satirizes the merchants, while another of his images of a peasant festival flies a flag saying 'let the peasants have their kermis!'.

As the genre of 'peasant-painting' developed through the centuries, there were many images where peasants merely decorated idealized bucolic scenes for bourgeois consumption, but you do still get instances of more interesting work. The nineteenth century is especially associated with the genre, and this is because it is yet another period of great social change, due to industrialization, and the figure of the peasant once again becomes contentious. Although it is now easy to argue that Van Gogh's or Cézanne's images of peasants still romanticize them, these artists had strongly political reasons for their subject-matter, and

**53**
'Harvesting plants for Pigment Making', from the exhibition *The Peasant Painter's Garden*, ASC Gallery, London, 2013
Courtesy the artist and ASC Gallery

**54**
*Museum Girl with Doll*, 2007
Mushroom pigment made from blood red webcaps
(*cortinarius sanguineus*), plant pigment made from
Lady's bedstraw (*galium verum*), indigo, zinc white,
chrome yellow and red lead bound in egg on
hand-woven linen, 102 x 96.5 cm
Courtesy of the artist and Annely Juda Fine Art

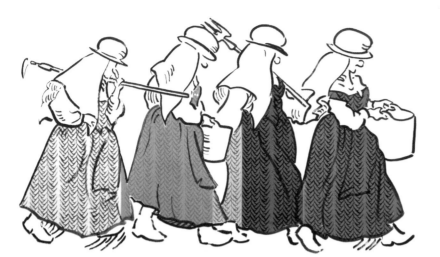

**55**
'Back from Work We Come', 2016
Ink and gesso on calico mordant printed with
madder, cochineal, dyer's broom, and buckthorn
berries, mounted on panel, 110.5 cm x 196.5 cm
Courtesy of the artist and Annely Juda Fine Art

the challenging manner of their paintwork hardly made them easy to sell to the urban middle classes at that time.

However, in my invocation of 'peasant-painting', I am interested not just in the history of 'paintings of peasants' but also of 'peasants that paint'. In south-west Sweden, from the second half of the eighteenth century to the first half of the nineteenth century, an extraordinary school of peasant painting (as in peasants that paint) flourished. These paintings in egg-tempera on old sheets and cloths were made by peasants and sold to peasants. They had a ritual use, being kept rolled up for most of the year, and only displayed for special occasions such as weddings and Christmas. In this sense, they have a remarkable congruence with images of festive peasants from the sixteenth century. Indeed, the images themselves fit with occasions both in their subject-matter and cheerful tone – the Marriage at Cana for wedding parties, images of sheep mating at the Nativity, representing fertility for Christmas! Since this was also the period that Sweden was undergoing land reforms which resulted in the break-up of villages, I believe that we can see this painting practice as a form of resistance and an expression of community. Turning attention to 'peasants that paint' allows us to see peasants not just a figure of 'the other' which served to construct an urban middle-class sense of self, but to also see them as protagonists with their own agency and creativity. It also allows

us to look outside the narrow confines of what has been determined as the narrative of Western art history.

In my reading of the 'peasant painter' I seek to unearth these various histories of the genre and [see] how they contribute to where we are now, and what other possibilities they may suggest for us.

**RS: Could you tell me about the role that making and sourcing particular pigments plays in your practice?**

SH: Making my own pigments and paints allows me to reconnect the materiality and histories of the pigments with the way they can generate meaning within a painting. It is widely understood that installation art harnesses the network of meanings associated with the materials used, but people have a tendency to take paint as a material for granted, focusing only the optical effects of the colour and image. In fact, Duchamp himself said that 'since the tubes of paint used by an artist are manufactured and readymade products we must conclude that all the paintings in the world are 'readymades-aided' and also works of assemblage'.[1] Although my paint is not readymade, it is part of an assemblage that includes using plants to make pigments, and using various historical recipes for the pigment-making process. Along the way, I discover the global and colonial trajectories of these plants and pigments, such as

cochineal and indigo from Mexico and Guatemala, or woad from Europe which has become invasive in Colorado and Utah. I also discover multiple uses for these plants, which include the medicinal, the magical and the sartorial. The pigments belong to an entire material culture, which makes up a world. It may not be a world we live in today, but it is a world that got us here, or it could be a world to come. Consequently, the pigments in my paintings don't just serve as colour making an image, but are also the physical presence of all these histories and processes that have gone into their making.

Moreover, in a certain way, cultivating and foraging these plants allows me re-enact being a 'peasant that paints' ….

**RS: Costumes and performance seem like a very important aspect of your practice – could you say a bit more about this?**

SH: I think of my practice as an expanded form of painting which includes every stage of the making – the cultivation of the plants and the pigment-making. Although my paintings still do get displayed in the white cubes of the gallery, I want them to maintain their connection to the wider worlds, the histories and the processes that have gone into their making, and not only be consumed for their visual effects. The performance allows me to bring these activities to light, and frame how the paintings are received, while at the same time the costumes prevent the performances from slipping too easily into the standard pedagogical format of the lecture or demonstration. Indeed, I have recently become increasingly interested in how the figure of the clown interfaces with the figure of the peasant. The authoritative position of the lecturer/demonstrator is somewhat undermined when it is given by a sixteenth-century peasant woman wearing a nose made out of a papier-mâché cucumber.

**56**
Pigment made from broom
(*genista scorpius*)
Courtesy of the artist and Joya:
arte + ecología

RS: You made a series of paintings inspired by living history museums in Sweden. Some of the works feature museum re-enactors dressed as peasants performing different tasks. You've also mentioned that you are part of a re-enactment group. Could you say something about your interest in re-enactment as a process and perhaps a political act?

SH: The living history museums in Sweden are fascinating. They presented a new way of displaying artefacts in their contexts, consisting of collections of rural buildings, with their interiors, furniture and everyday objects in situ. They were very much part of a nation-building project. At Skansen, which was founded in 1861 and is claimed to be the world's first, the buildings were laid out to reflect the geography of Sweden. The aim was ostensibly to preserve a disappearing rural culture, although, somewhat ironically, these open-air museum associations were often led by the very industrialists that were instigating these social changes. On a more fundamental level these open-air museums represented a particular conception of ethnography. It was an ethnography that was based on notions of human progress and evolution, as exemplified by Sven Nilsson's mid-nineteenth century book *The Primitive Inhabitants of the Scandinavian North*, in which he described four stages of cultural transition – from hunting and fishing to pastoralism to agriculture and finally civilization. The open-air museums therefore represented the last stage in agriculturalism before the progression to civilization and modernity.

In one open-air museum where I was artist in residence in 2011, in Halmstad, Sweden, I discovered that in the early days of the museum, the founder, [the] industrialist Alfred Wallberg, had installed an old ex-worker from his brick factory, called Nelly, ostensibly as a live-in 'caretaker' and 'storyteller'. The brick factory was situated on the outskirts of the city and it is likely that she lived rurally and had ended up working there in order to supplement her income owing to a lack of land. She lived at the museum more or less against her will, and found it very lonely during the dark nights of winter. Rather than really taking care of the museum, poor old Nelly seems to have been employed as a museum exhibit, in the strange position of re-enacting herself, representing a pre-modern world.

Despite these problematic beginnings to open-air museums, I feel that these spaces made important changes to what we think of as the museum and have a continued political potential. I think it is positive that the history of everyday life is represented, rather than merely artefacts associated with the aristocracy, and the integration of these artefacts into their wider material culture and world works against the fragmenting effects of the classical museum vitrine. Re-enactment is obviously a method I employ myself. I think it is a powerful way of generating other types of knowledge that cannot be accessed through texts. The bodily experience of performing certain tasks and processes, and of re-making things using period materials, provides an understanding that could never be obtained through written documents. Nonetheless, there is a certain disdain on the part of academia towards re-enactment because it is seen as too subjective. I would argue that this reflects a deeply problematic hierarchy of knowledge, which privileges analytical distance and the written word over bodily and practical ways of knowing, and by extension privileges Western academic modes of knowledge over non-Western, or non-elite, knowledges.

In fact, practice-based research does not preclude rigour: the re-enactors that I have worked with are highly meticulous in their research, and do not entertain romantic notions of life being better in the past. However, they do really enjoy themselves, and perhaps this is the most political act of all. I have been told that, in comparison to the alienating effects of the weekday job, spending the weekend in a living history museum feels much more like real life.

**NOTE**

1  Marcel Duchamp, 'Apropos of "Readymades"', lecture at the Museum of Modern Art, New York, 19 October 1961, in *Art and Artists*, vol. 1, no. 4, July 1966.

# GB FARMING: FOURTEEN FARMS, EIGHT MONTHS

GEORGINA BARNEY

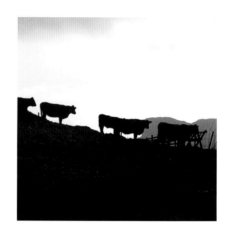

London is a place to begin journeys, never to end them. Was he right ... are all journeys out of London 'flights'? Am I attempting to escape – will the sirens of the capital call me back one day?

Woke up knackered and aching after yesterday wheel-barrowing manure and trailerfuls of seaweed around the garden. Rich wet colours, the squelch of shit, wet greens, the spray of the sea: satisfying and sensuous – but my body is reaping the rewards today.

Around 3 o'clock on Eigg, like the shadow of a sundial the half dozen cattle move across the field towards the gate. The sound of their low groans is a gentle alarm, signalling feeding time and your last chore.

**19 January 2007**
**Journey North**

**30 January 2007**
**Ullapool**
**Ross-shire**

**12 February 2007**
**The Isle of Eigg**
**Outer Hebrides**

A gentleman had been found poking with his walking stick in a plant bed where a highly desired snowdrop species was growing. Specialist cultivars can sell for £80 but there areplants that money cannot buy, I'm told, 'only love'.

**27 February 2007**
**Cambo Estate**
**Fife**

There is a striking incongruity to farming. Endangered lambs are frequently brought into the farmhouse to warm up before the Aga, but they're also often dying. Its death might coerce a 'poor wee soul' from one of the family, but it won't be mourned for long.

**24 March 2007**
**Over Langshaw Farm**
**The Scottish Borders**

Silage bales, wrapped up like blown-up sweets, the evening light playing colourful havoc on the surface of the black plastic – soft purple-grey dried mud stain; glistening, fecund aubergine skin; at the centre a golden spot, caught light, glitter of expensive orange

**1 April 2007**
**Broxfield Farm**
**Northumberland**

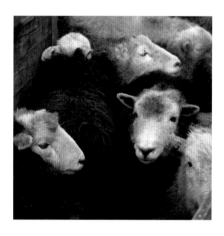

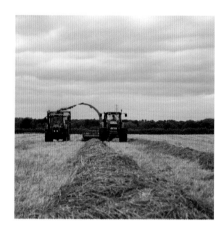

A night-time whip round: three ewes recently lambed, and a fox barking nearby in the wood. Scooted round in the quad bike, picking them up to bring them in. Sheep look unearthly under headlights and torches, eyes glinting back in the dark.

To the abattoir: skips and machinery that you don't know the use of are terrifying. And the men: all these men, wearing plastic deep-red aprons, white cotton jump-suit overalls over bare arms, orange ear-muffs and clean yellow plastic boots. You wonder what they do and how.

I like the scale of pure matter, and the way in which it is (re)cycled (a)round. Grass becomes milk and flesh and shit. Shit becomes grass again. Material changes. Lots of it; grass is piled up, piled up, and a year later it is silage. It was the ground; now it's a thing ....

**26 April 2007**
**High Wallabarrow Farm**
**Cumbria**

**6 May 2007**
**Whirlow Hall Farm Trust**
**Sheffield**

**25 May 2007**
**Walford Farm**
**Walford and North Shropshire College**

Freddie a pure businessman, farming as pure capitalism; Longhorn cattle in park as Animal, Meat, Cash, Tradition, Image, Local Story, Colour, Smell, Sound.

Huge machinery, rolling over black and green ground. Inside 'the rig' lettuce from the ground is being transformed into an object ready for the consumer. This is an industry, like digging for oil.

Cutting garlic stalks and their mudded hairy ends into a bucket in front of a DVD in the kitchen. A pile of onions, green and brown wet stalks hanging off the ends, on a shelf in a makeshift smoke-room. The smell of them.

**6 June 2007**
**Quenby Estate**
**Leicestershire**

**20 June 2007**
**G's Marketing**
**East Anglia**

**4 July 2007**
**Old Forge Farm**
**Carmarthenshire**

Working outside on the vines. Up and down most of the day. I know how long it takes me to do a row, how many rows to an hour, how many before morning tea-break, how many before lunch.

**19 July 2007**
**Sedlescome Vineyard**
**East Sussex**

Images of myself: sweating from the strain of carrying bags of potatoes on my back up the hill; sweating in the sun, scything in shorts and a bikini top; a sleeping cliché underneath an apple tree with battered straw hat over my face.

**1 August 2007**
**Tinker's Bubble**
**Somerset**

On my way home I sat and talked with Michael in his garden for a long time. Education work had enabled him to feel positive about farming again – he had been wondering 'if anyone cares about us and what we do'.

**11 August 2007**
**Pentiddy Woods**
**Cornwall**

# INGRID POLLARD

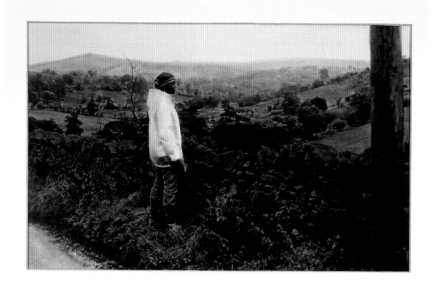

... **Searching for sea-shells; waves lap my wellington boots, carrying
lost souls of brothers & sisters released over the ship side** ...

**Rosemary Shirley (RS): Your work 'Pastoral Interlude' (1988) is a series of photographs showing black men and women in rural locations. Each image is accompanied by a stream-of-consciousness text connecting the figure with feelings of unease together with references to colonial and British histories. Could you tell me about the inspiration for these works and how you feel about them almost thirty years on?**

Ingrid Pollard (IP): I look at them now and I see how nicely tinted they were, the images are much more delicate in the flesh than in reproduction. When considering the work people seem to be obsessed with the words rather than the images. The text mentions unease so therefore people tend to think I must feel alienated. I consider it to be much more subtle than that. The words and the images work together in more poetic ways. The language references William Blake and echoes Wordsworth's poetry, but the images are snaps from family albums. I'm interested in how family album photography is so often just dismissed. In 'Pastoral Interlude' we see a woman in a pastoral landscape, but she is wearing trainers not walking boots, a plastic mac, not a fleece. Which can be seen as indicators of her intentions and familiarity with walking. The images are tinted; their look emphasizes a sense of the romance of rural landscape. The rural is traditionally – certainly within the language of tourism – seen as a place of romantic rural idyll of timeless, unchanging nostalgia. She gazes over a managed and developed landscape. But the landscape she looks at is, for me, just as managed and constructed as an urban landscape. The longevity and the sustained interest and exhibiting of 'Pastoral Interlude' emphasizes its continued relevance to a whole range of issues beyond the 'politics of identity' that it is usually positioned in.

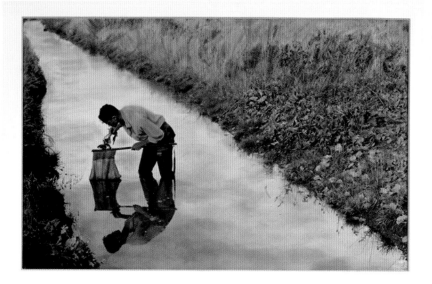

**57b**
*Pastoral Interlude*, 1987
Gelatin-silver print,
coloured by hand, 25 x 38 cm
Arts Council Collection © The artist

... **death is the bottom line. The owners of these fields; these trees and sheep want me off their GREEN AND PLEASANT LAND. No Trespass, they want me DEAD. A slow death through eyes that slide away from me** ...

RS: Traditionally Toile de Jouy designs represent a fantasy of the rural idyll – the pleasures of the countryside. Your take on this classic design, *There was Much Interruption*, references modern-day rural labour, as well as the histories of world trade, exploitation and slavery. Could you say more about your interpretation of this design?

IP: This wallpaper work was made during an artist's residency in the rural area of Picardy in northern France. My bedroom was papered with slightly old and yellowing Toile de Jouy wallpaper. And, during a previous residency in Northumberland, I had and stayed in a room which had a newer version of the same design.

In France I started to pay attention to the wallpaper more and more and began to understand it as a fantasy of the rural life around me. It seemed to represent a contrast between people who worked the land and the people who owned it. The dancing, wine-making, farming and music-making activities depicted echoed the scenes I saw around me. I was surrounded by a landscape of wheat, cornfields and also a large sugarbeet factory. I cycled to the local farm for milk; sometimes I was able to attach the milking machine to the cows and take away the milk that had just been produced.

Incidentally, during this time I was undertaking a residency in Lancashire, in a disused cotton mill. I was thinking about the cotton industry, the mill-workers and the cotton growers, the landowners and the distributions of wealth going back to the days of trans-Atlantic slavery. While I was travelling between these two places these two sets of ideas were mushing together. That's one of the reasons why the work is called *There was Much Interruption*, as I broke from one location to the other. I was thinking about people who had worked with cotton, on the land, in the mill, and also those toiling in the grounds of the French château.

At this time I also happened to buy a photographic glass plate showing a traditional textile printer in Kumasi, Ghana. Kumasi has a long history as the established centre for the production of traditional West African printed textiles. However, the worker pictured in the glass plate is making prints in a very hands-on way. The fabric is laid out on the ground of the village outside – what looks like his dwelling – while a finished one hangs up next to him to dry. It took a little fortuitous research to find out that the tools the printer was using – or some very similar ones – are held in the British Museum. All these motifs – of cotton mills, of rural workers and of artisans – circulate together in my wallpaper design, which represents these connections through history, labour and world trade.

**58**
*There Was Much Interruption*, 2015
Wallpaper, 1200 x 56 cm
© The artist, courtesy of Hollybush Gardens

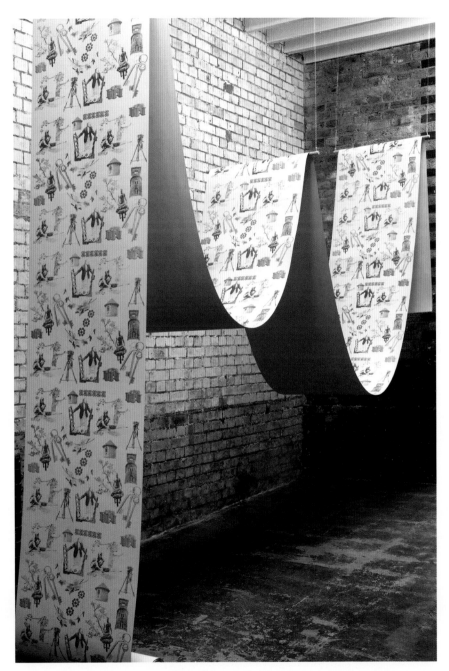

# The Nature of Nostalgia

NICOLA BISHOP

Across Britain, nature is in vogue, the countryside is the new chic. The vintage pastoral patterns of Cath Kidston, the bright floral designs and gentrified tweed of Joules, and Hunter welly-clad urbanites boldly proclaim the rural as a middle-class fashion statement. A perceived 'nature deficit' has fuelled a new interest in all things rural, rustic and wholesome, as seen in the expansion of charitable organizations like the National Trust and the Royal Society for the Protection of Birds (RSPB). Membership of such associations is at an all-time high: in 2010, the number of RSPB members stood at more than double that of the three major political parties.[1] Both now place new emphasis on family adventures in the outdoors; the new 'natural playgrounds' of the National Trust parallel the growing Forest School movement.

In bookshops, 'new nature writing' dominates the shelves whilst window displays are full of bucolic book-covers, nature lino-prints and matching floral tea-towels. Essayists, anecdotal writers, prose-poets, and natural historians like Robert Macfarlane, Kathleen Jamie, Roger Deakin and Helen MacDonald (to name but a few) call us back to the wild, opening our eyes to their landscapes (and ours) with beautiful and nostalgic evocations of what we are missing in the twenty-first century. Often, this nostalgia drives the authors backwards, to a lost landscape that is at once more remote and free of human interference (except that of the lonely poet). Sometimes it is conflicted: Jamie has criticized the romanticized stance of the 'lone, enraptured male' nature writer, with time and funds to conquer far-off Celtic fringes.[2] Others argue that, when the rural is eulogized, the urban becomes lamented. In dialogue with this stance, authors like Paul Farley and Michael Symmons Roberts call for us to look at the urban wilderness – the edgelands reclaimed by nature; wastelands and railway verges that speak of a renewed ecosystem.

At the same time, works of an earlier generation of nature writers are finding a new audience. Sold alongside the new nature writing, these early and mid-twentieth-century writers recall a simpler, and more pure pastoral time. With wistful covers that reinforce the associations between the rural and the nostalgic, they are often to be found near the British Library Crime Classics – reprinted novels from the 1930s and 1940s. The content and form, taken together, demonstrate a much broader trend for mid-century design and country life, exhibiting a sentimentality towards an imagined pre-urban idyll. Contemporary publishing and marketing also finds and fosters purposeful links between old and new nature nostalgia. When buying a book by Robert Macfarlane online, costumers are 'recommended' H.E. Bates, W.G. Sebald, W.H. Hudson or Edward Thomas. Many of the new nature writers – consciously and unconsciously – reinforce this literary lineage by referring to the influence of these same writers. So, too, do the prizes

**59**
**GRAYSON PERRY**
*Fantasy Village*, 2006
Glazed earthenware, 57 x 33 cm
The Collection: Art & Archaeology in
Lincolnshire (Usher Gallery, Lincoln)
© The artist, courtesy of Victoria Miro
Gallery, London

awarded to exceptional works of nature writing: the 'Wainwright' prize is a good example. Simultaneously referencing the Lakeland guidebook writer and the Wainwright brewery (the revival of real ale itself is another reflection of the popular, historical rural), the prize is also sponsored by the National Trust.

In addition to literary eulogies, the old and organic are also increasingly commodified into attractive accessories and sold as 'vintage' – the detached and dehistoricized artefacts of the rural, quaint and 'authentic'. Vintage, like nostalgia, speaks of a past that floats freely across the twentieth century. See, for instance, the homespun arts, crafts and upcycling of programmes like Kirstie Allsop's *Handmade Britain* (Channel 4, 2012), in which Kirstie (cousin of Cath Kidston) needlefelts a delicate robin, bakes scones, and arranges flowers for country shows around the UK. Rural 'styles' – the delicate buds of a mid-1950s flower print, heathery tones in a mock tweed, the pastel shading of an indomitable Aga – co-opt a series of generalizations about the past that are not fixed. Interwar railway posters celebrating the Lake District and the Norfolk Broads, with their bright geometric designs, co-exist alongside Shaker kitchens and mid-century mock Scandinavian florals. Not confined to interior design, the trend has spread to the festival movement, as any episode of *George Clarke's Amazing Spaces* (Channel 4, 2012–) attests: 'vintage' vehicles turned into festival pop-ups are the new way to sell anything from coffee to cheese, hair-dressing to cinema-going.

Turn on the television in the evening and see a proliferation of what Felix Thompson called the 'geography genre'[3] – the televisual equivalent of nature writing – programmes like *Countryfile* (BBC, 1988–), *Scotland's Wild Heart* (BBC, 2016) and *Great Canal Journeys* (Channel 4, 2014–) that offer high-definition panoramic visions of the countryside around us.

The BBC's flagship rural affairs programme has long been criticized as an urban fantasy rather than a rural affairs programme, just as John Betjeman said, long ago, that the term 'countryside' itself is simply a 'delightful suburbanism'.[4] George Monbiot argues that *Countryfile* 'portrays the countryside not as it is, but as we would like it to be – timeless, unsullied, innocent, removed from the corruption and complexities of urban life'.[5] In the same way, there is an undisguised (in fact purposeful) sentimentality about much of this geographical programming. *Great Canal Journeys*, presented by Timothy West and his wife Prunella Scales, is unusually self-aware in this respect, charting, as it does, the historical development of Britain's canals alongside reminiscence of the presenters' idyllic family holidays and Prunella's waning memory (she has dementia).

Similarly, at the time of writing, *Penelope Keith's Hidden Villages* (2014–) is advertising its third series. This type of programme might be called 'docu-lite' – popular magazine programming that offers a series of info-nuggets about landscape, history, geography, literature, tradition and local anecdote. A subgenre that could be dissected along the lines of the 'dumbing down' of television (we do not, it suggests, have the attention span for 'proper' documentary any more), it is also usually countryside-focused. Indeed, the format is unusually uniform regardless of the broadcaster: a famous figure, often of a certain age (say Griff Rhys Jones, Richard Wilson, Clare Balding or Michael Portillo), makes a journey (following a nineteenth-century railway guide, a 1950s Shell motoring guide, or a cycling guide, or on foot), and offers an exploration of local areas of cultural or historical importance along the way. The premise is usually retrospective and focused on the intangible and the nostalgic – as Robbie Coltrane so neatly puts it in the opening to *B-Road Britain* (ITV, 2007): 'I will

be travelling ... the way that we would have done fifty years ago. And I'll be trying to find the real heart and soul along the way.'

While, as Helen Wheatley points out, these nature programmes dominate television schedules, elsewhere the landscape – as icon, image and idea – also shapes many other productions.[6] The BBC's recent remake of Tolstoy's *War and Peace* (2016) featured loving and lingering shots of the Russian landscape of a sort unfamiliar to earlier adaptations (although even the final episode was beaten in the ratings by a weekly episode of *Countryfile*). Likewise, the BBC's new flagship, *Poldark* (2015–), has devoted much time to visualizing the pastoral and picturesque (as well as celebrating the rugged masculinity of the lead character). In addition to popular productions which construct the landscape as televisual vista, audiences are also fed nostalgic representations of the rural. Consider the quintessentialism of *Midsomer Murders* (ITV, 1997–) – the quaint and idyllic villages and farmlands from which the cry of the fox gives warning to a brutal and initially unfathomable murder. *Midsomer* is a near relation to *Penelope Keith's Hidden Villages*: take out its terrifying social friction writ violent, and you are left with a lyrical portrayal of village choirs, arts festivals and close-knit communities protecting their semi-rural lifestyles. It coincides with a wider appreciation of the country fair, the vintage showcase (usually combined with a countryside location), and the *River Cottage* organic idyll.

Imported from Scandinavia, slow television takes these trends even further. Built upon the 'slow' movement – which takes an anti-urban, anti-frenetic stance on all aspects of life – slow television in Britain has developed into a paean for the rural. *All Aboard: The Country Bus* (2016), following two previous BBC4 slow television experiments, *Dawn Chorus* (2015) and *All Aboard: The Canal Boat* (2015), covers the entirety of the Northern Dalesman bus route, setting off from Richmond in Yorkshire and taking the audience on a 'lush and varied route, along a river valley thronged by blossoming hawthorn trees, through ancient mining villages and wild flower-filled meadows'.[7] The *All Aboard* series takes rural lifestyle programming and the philosophy of the slow movement and combines them into a product that enhances both. The author of *In Praise of Slow* (2004), Carl Honoré, talks about the BBC's slow programming as a timely reaction to the ongoing cycle of diminishing attention-spans (either real or assumed) and the quickening tempo of television.[8] Landscape television, then, offers respite from the speed of contemporary drama, as well as relief from what Simon Heritage called the 'slate-grey urban misery'.[9] The presenters of *Autumnwatch* (BBC, 2006–) have even cautioned viewers about addiction to a vision of rurality that replicates the 'fix' that comes from visiting a nature reserve, while ignoring the 'sterile, too intensely farmed' landscape en route.[10]

In Channel 4's social experiment/reality television show *Eden* (2016), it was not only the beauty of the Scottish wilderness that aimed to draw the viewer in, but the supposed wildness of that wilderness. Predictably, the series actually provides a heart-warming cycle of challenge and communal unity, rather than an apocalyptic eruption of social discord or natural disaster. Like Macfarlane's *The Wild Places* (2015) and George Monbiot's *Feral* (2013), it signposts the televisual trend not only towards nature and the countryside but also 'rewilding' – the notion that we are lost to an urban lifestyle, and disconnected from our ancestors and native land. Macfarlane points to the moment that 'BlackBerry' (the mobile phone) entered the *Junior Oxford Dictionary*, and 'blackberry' (the hedgerow fruit) was left out, as symbolic of a new age in which technology usurped nature.[11] Another example is the popularity of the digital game *Pokémon*

*Go* – in which digital symbols are mapped on to real-world locations, with game players mediating the landscape through their phones as they collect their Pokémon. After its launch, the press was full of examples of careless phone-gazers endangering their lives by entering hazardous environments without due attention. With people stuck on sand-banks with the tides racing in, or dressed in shorts and a T-shirt on a mountain precipice, these incidents demonstrated the disconnect between the young (in particular) and their landscape.

Perhaps the most notable feature of this new nature-fashion is the growing disconnect between what we enjoy about the countryside, how we feel about 'nature', and what we truly understand about the 'wild'. While reading *The Wild Places*, watching *Countryfile*, and weekend outings to bird reserves and National Trust parklands ease our supposed nature deficit and give us that 'natural high', the aesthetic and nostalgic aspects of our new fad risk overshadowing the conservation, preservation and ecological issues that are ultimately at stake.

NOTES

1 'More people than ever saving nature' (11 May 2010); http://www.rspb.org.uk/ news/details.aspx?id=tcm:9-251587.

2 Kathleen Jamie, 'A Lone Enraptured Male', *London Review of Books,* vol. 30, no. 5, 6 March 2008.

3 Felix Thompson, 'Is There a Geography Genre on British Television?: Explorations of the Hinterland from *Coast* to *Countryfile*', *Critical Studies in Television,* vol. 5, no. 1, 2010, pp. 57–68.

4 Sam Creighton, television reporter for the *Daily Mail*, talks about about *Countryfile* often being renamed 'Towniefile' or 'Countryfool' because of its focus on the 'fluffier side of the rural community': #towniefile also trends during the show's broadcast on Sunday evenings. Sam Creighton, 'It's Towniefile! Disgruntled farmers say BBC rural affairs show is too "London-centric" and doesn't

engage with issues facing them' (5 June 2015), *Daily Mail*; http://www.dailymail. co.uk/news/article-3111612/It-s-Towniefile- Disgruntled-farmers-say-BBC-rural-affairs- London-centric-doesn-t-engage-issues- facing-them; html#ixzz4MDMEe5ci; Philip Lowe, 'The Rural Idyll Defended: from preservation to conservation', in G. Mingay (ed.) *The Rural Idyll*, London: Routledge, 1989, pp. 113–31.

5 George Monbiot, 'Rural Idiocy' (10 September 2015); http://www.monbiot. com/2015/09/10/rural-idiocy/.

6 Helen Wheatley, 'Beautiful Images in Spectacular Clarity: Spectacular Television, Landscape Programming and the Question of (tele)visual Pleasure', *Screen*, vol. 52, no. 2, 2011, pp. 233–48.

7 'All Aboard: the Country Bus'; http:// www.bbc.co.uk/programmes/b07r2s1r.

8 John Plunkett, 'Gently Does it: from

Canal Trips to Birdsong', *The Guardian*, 1 May 2015; https://www.theguardian. com/media/2015/may/01/gently-does- it-from-canal-trips-to-birdsong-bbc4-to- introduce-slow-tv.

9 Stuart Heritage, 'Countryfile v War and Peace: how a farming magazine beat Tolstoy on TV', *The Guardian*, 13 February 2016; https://www.theguardian.com/tv- and-radio/2016/feb/13/countryfile-v-war- and-peace-how-agricultural-magazine- beat-tv-biggest-drama.

10 John Plunkett, 'Wildlife shows not reflecting reality of natural world – Springwatch presenters', *The Guardian*, 24 May 2016; https://www.theguardian. com/tv-and-radio/2016/may/24/wildlife- shows-not-reflecting-reality-of-natural- world-springwatch-presenters.

11 Robert Macfarlane, *Landmarks*, London: Hamish Hamilton, 2015, p. 3.

# DELAINE LE BAS

**Rosemary Shirley (RS): Much of your work investigates and records the representation of Gypsies in art, the media and popular culture: can you tell me more about this?**

Delaine Le Bas (DLB): As a people we are highly visible, but it's usually in a negative context. We are always described as if we have just 'landed', even when we have a long history of connection with a place. This is true in both urban and rural contexts. The story never changes. If you look at an article from *The Illustrated London News* from the 1870s, for example, you will see the same language used to describe us that you will see in *The*

*Daily Mail*, *The Daily Express* or *The Sun* today. By juxtaposing historical documentation with contemporary depictions and descriptions we open up a debate around racism and representation. It also exposes the myths of 'sudden invasion by Gypsies' for what they are. It exposes the reality of both historical and ongoing racism. Many people would rather not be confronted with all this: it's easier to pretend it isn't happening, or that it's not serious. Gypsies are far from alone in experiencing the current geopolitical lurch to the right. It's rearing its head at many people, not just us.

**60**
*Part Of The Landscape Of This Green And Pleasant Land I*, 2008
Double overlay photograph
© The artist

**61**
*Part Of The Landscape Of This
Green And Pleasant Land II*, 2008
Double overlay photograph
© The artist

**RS: How do you see the relationship between Romany peoples and landscape or the idea of the rural idyll?**

DLB: It is a strange relationship. On the negative side, it often goes hand in hand with the portrayal of 'sudden landings' of Gypsies, and the ignorance of our historical connection – often well documented – with places which depended on Romany labour and had long-established 'atchin tans' (traditional stopping places). It also prevents people from seeing that not all of us are nomadic, but that we remain ethnic Romanies nonetheless. The romantic, mythical Gypsy in the painted caravan with the black-and-white horse is only one aspect of a complicated picture. The oversimplification of this picture has bred false ideas of purity and authenticity and of who is and who is not a 'real Gypsy': one

of these is the belief that it is easy to 'spot' a true Gypsy, which is insulting and often untrue.

Many Gypsy families have intimate connections with particular places and areas due to work patterns across decades, often centuries. As an example, my own family have a deep connection with the village of Binsted in Hampshire. They worked there consistently over many years on particular farms. Four generations of my family are buried in the old churchyard there. We are not alone in having particular relationships with places within the rural idyll, but we are still seen as having no right to these spaces: we do not belong there, and for many people we do not belong anywhere. One cause of this is a lack of visibility in museums and art galleries, often alongside poor curation of collections and exhibitions. It is absolutely not down to a lack of material. There are

copious depictions of Gypsies in paintings, drawings, prints, photography, antique objects and other forms of documentation including books and film. The lack of awareness of this material has allowed negative and stereotypical portrayals to flourish in the media. This in turn has aggravated situations, constructed bad relationships, fed conflict and cultivated fear.

**RS: It seems as if an important part of your work involves engaging with archives and collections. Can you say more about this?**

DLB: The work I have done with archives and collections (including at Worthing Museum & Art Gallery, the Museum of East Anglian Life, Bolton Museum & Art Gallery, the Special Collections at Liverpool University, the Pitt Rivers Museum, and the Turner Collection at Tate Britain) has only scratched the surface

**62**
*Swear To Tell The Truth Part II*,
30 January 2016
Photographic documentation
of performance
© John Puddephatt

in terms of what is out there. It is deeply frustrating to realise that the reason we are not visible in libraries, museums and archives is not because there is a lack of material, but because it is hidden from view, whether deliberately or through simple carelessness. There are many historical depictions of us in the city as well as the countryside, but there is a lack of will to include this material in exhibitions. This has to change in order to create a much more accurate picture of our place within British history, which would lead in turn to a more nuanced view of British history in general. To take a typical example, in 2012 I visited the show *Migrations: Journeys Into British Art* (Tate Britain, 31 January –12 August 2012). The curators wrote that 'This exhibition explores British art through the theme of migration from 1500 to the present day'. Considering we are one of Britain's oldest ethnic minorities – we have been in the UK since at least 1500 – and have at times been synonymous with migration, it seemed strange to me that I could not find a single depiction of Gypsies to be seen anywhere within this exhibition. Considering the number of items there are within the Turner collection itself, let alone other paintings of Gypsies which are held by the Tate, this does nothing to dispel the completely false myth that we have just landed and are not part of the country's past.

Much of the work I have been doing relating to collections and archives involves making these historical documents visible, and thereby placing us where we always have been, firmly within Britain's history.

**RS: Can you tell me about the importance of textiles and fashion in your work?**

DLB: I studied Textiles and Fashion, completing my MA at St Martin's School of Art, London. I grew up at a time when certain hairstyles, jewellery and items of clothing made you easily identifiable as a Gypsy. As a child I grew up being dressed in a very particular way, including at school, which marked me out as coming from my community. As I was growing up I had an interest in clothing, probably because of all this. I loved music and was especially inspired by Punk. Polystyrene from X Ray Spex was one of my heroines. The idea of dressing to suit to yourself was something that I related to, and the idea of people not liking it and verbally and physically attacking you because of it was something that I had already been dealing with since I was a small child. I didn't question the fact that this happened, I was simply interested in why it happened. Being the other, not conforming, being singled out …. All these were second nature. I was used to these things, and for me it has been and remains a comfort to know that styles of clothing, particular patterns and prints … these things are not just positive signifiers. They can also symbolize and embody an act of rebellion against the status quo.

**NOTE FOR READERS**
DLB: I am happy to use the word Gypsy, but increasingly – and especially in mainland Europe – this is not the politically correct term, and there is much debate and conflict about the use of the word. Since I do not try to force my opinion upon others as to what they call themselves, I can only hope that they might grant me the same courtesy.

# Smells like Rural Idyll

ROSEMARY SHIRLEY

A woman stands on a cliff top, now it's a moorland, now it's a wide valley. Her long hair blows gently in the breeze as she inhales deeply, conspicuously filling her lungs with the scent of the great outdoors. Fresh air. Seamlessly she is transported to a workshop, where, surrounded by leather-bound volumes and antique-looking glass vessels, she mixes a potion in a tiny bottle. She smiles as she presents it to the camera – she has captured the fragrance of the UK's national parks. You too can enjoy this bouquet from the comfort of your own home, with Airwick's national-parks-themed air-freshener range.

At least you could. At the time of writing this essay, these products are coming to the end of their time in the sun. The magic commodity dust, sprinkled on them by copious TV advertising and supermarket promotions, has all but rubbed off. Only the odd one can still be found lingering in the household-goods aisle.

In 2013–14 National Parks UK developed the brand Britain's Breathing Spaces, derived from the East Anglian naturalist Ted Ellis's description of the Broads as 'a breathing space for the cure of souls'.[1] It was decided that the fifteen parks needed to be marketed as a recognizable group of tourist destinations – a 'family of parks' rather than as individual and very different places.[2] The name was also given to a unit set up to cultivate corporate partnerships for the parks. The move was in response to a cut in public funding of around 40% and a government recommendation that the shortfall should be generated through partnerships with the private sector.[3] In the USA national parks have sourced funding in this way for years.

The US parks website has a list of companies who are proud to sponsor the parks, including big-name brands like Coca-Cola, Budweiser, Toyota and Disney. In 2016 new regulations were proposed to increase the visibility of corporate sponsors, in a move designed to attract more lucrative sponsorship deals. This would include the opportunity for businesses to name certain features in the park and display their logos on buildings, pathways and National Parks Service signage – all attractive opportunities for companies wishing to connect themselves with nature.[4]

Airwick's first collaboration with national parks happened in the US and formed the foundations of their partnership in the UK. Given the Breathing Spaces brand name, it seems simultaneously fitting and deeply strange that one of the first of these corporate partners trades heavily on the idea of fresh air and at the same time creates products that use chemicals to simulate this experience indoors.

So what should the Peak District smell like? For that matter, what about the Lake District, Exmoor or the Brecon Beacons? Predictably, the smells often encountered in these places, such as farm manure and exhaust fumes, are not represented in the range. Some of the products could claim some relationship to the park they represent – for instance, the New

63
**PAUL HILL**
*Legs over High Tor, Matlock*, 1975 (detail)
Vintage gelatin silver print,
25.4 x 20.3 cm
© The artist, courtesy of The Hyman
Collection, London

Forest is captured by 'Golden Woodlands and Sweet Nectar', which could be a reference to the abundance of gorse on the area's heathland, and the Yorkshire Dales fragrance features a white rose, the symbol of the county. The Peak District, however, is represented by 'Spring Breeze and Golden Lilies', and while it would be difficult to dispute the presence of seasonal breezes, in my experience as a resident of the area golden lilies do not feature heavily, in fact as a native species they are entirely absent.

These products are interesting because, while the fragrances they have created have very little to do with the individual national parks to which they are linked, they draw on and reflect culturally ingrained fantasies of the rural idyll. This is primarily done through language, with the names of these products encompassing a range of powerful cultural responses to the landscape. The Lake District fragrance 'Midnight Berries and Shimmering Mist' conjures a mystical landscape, with fruits gathered at the witching hour in a rising mist, shimmering with druidic potential, redolent of Blake or Palmer. The Yorkshire Dales fragrance 'White Roses and Pink Sweet Pea' seems to describe a cottage garden straight out of a Helen Allingham watercolour (see fig. 64). Descriptors such as 'Snowy Mountain' (for the Cairngorms) and 'Mountain Sunset' (for Snowdonia) come out of the Romantic sublime landscape tradition, with Caspar David Friedrich's lone wanderer, staring off from a mountain peak into the unknowable vista. 'Sea Spray and Ocean Minerals' (for Exmoor) and 'Wild Blossom and Fresh Mountain Dew' (for the Brecon Beacons) draw on the tradition of rural places as clean and health-giving and, by virtue of this, morally better alternatives to the dirty, unwholesome city. This is an association which can be seen in some of the very first landscape paintings, from the fifteenth century, which featured St Jerome seeking spiritual solace in rural retreat, the city of corrupting influence often depicted in the distance. Later, writers such as Henri David Thoreau in *Walden: or Life in the Woods* (1854) and Ralph Waldo Emerson in his essay *Nature* (1836) were advocates for life lived closer to nature.

The stories we are repeatedly told and continue to tell ourselves about rural places can be thought of as mythologies. Roland Barthes wrote a collection of essays entitled *Mythologies* in the early 1950s. This was a time when French society and Western culture in general were undergoing significant change – specifically, the development of mass media and consumerism. Barthes took his subjects from everyday life, musing on the emphasis of foam in soap-powder advertising, the haircuts of the Romans in the Hollywood blockbuster *Spartacus* and the popularity of steak and chips. He was interested in exposing what he called 'what-goes-without-saying' and 'the falsely obvious':

> The starting point for these reflections was usually a feeling of impatience at the sight of the 'naturalness' with which newspapers, art and common sense constantly dress up a reality, which, even though it is the one we live in, is undoubtedly determined by history. In short, in the account given of our contemporary circumstances, I resented seeing Nature and History confused at every turn, and I wanted to track down, in the decorative display of *what-goes-without-saying*, the ideological abuse which, in my view, is hidden there.[5]

For Barthes, myth is what turns history into nature. This is an ideological process in which that which has happened is made to seem as if it was always going to happen because it is the 'natural' state of things. This justifies current conditions and shuts down the possibilities for imagining something different.

**64**

In his recent re-working of *Mythologies* to reflect contemporary Western culture, cultural historian Peter Conrad suggests that what Barthes was analysing is what we would now call branding.[6]

In the twenty-first century branding is a powerful creator and distributor of mythologies. In everyday life we operate in a space between being highly susceptible and highly sceptical of its powers. Some small part of us might choose a national parks air freshener because we long for an idealized outdoors experience, while one part of us is just seeking the solution to an odorous downstairs loo.

We have seen how this brand partnership between the national parks and Airwick has created products which draw on well-established rural mythologies, constructing the countryside as a place which is mystical, sublime, beautiful and healthy – but neglecting the fact that the parks are also places that are lived in, worked in, farmed, managed. However, they also disseminate a visual mythology which

flattens out the parks, ironing away differences, difficulties and the specificities of these diverse landscapes. They feed into the largely urban myth that the 'countryside is the countryside' – a picturesque tract of sameness which fills in the spaces between towns and cities. In the TV advert the perfumier is transported between three different national parks but they all look the same, each one a mixture of computer-generated blue sky and green hills. In addition, the illustrations on the air-freshener packets are dominated by images which relate to aspects of the fragrance (berries, flowers, spices), each with a generic-looking landscape as background.

There are fifteen national parks but only eight fragrances, meaning that almost half of parks are not represented in this high-profile partnership. It would make sense for the manufacturers to include the most visited parks in the range – the top three are the Lake District, the Yorkshire Dales and the Peak District[7] – but after that, how are the decisions made to decide what's in and what's out? I would argue that the parks that do not conform to the easy blue-sky green-hills version of landscape, or are more difficult to visualize, are excluded. The Broads National Park in Norfolk, for example, does not appear in the range. The Broads are a complex network of waterways and flooded medieval peatlands, an unusual topography that does not easily translate into the mystical/beautiful/sublime/healthy set of rural mythologies (and might actually conjure unpleasant smells in the imagination). Similarly the South Downs are out – perhaps a 'down' is not recognizable enough as a type of landscape. Exmoor is included but Dartmoor and the North York Moors are not. If you come from the position that one moorland is very similar to the next, then these omissions make sense.

While I am not suggesting that we should look to an air-freshener range to represent rural places in all their rich complexity, I am arguing that these mass-produced and mass-marketed products contribute to the circulation of a set of rural mythologies which generate stereotypical and etiolated representations of rural places.

Over the last decade, these images of the countryside have proliferated in contemporary UK society: it seems we are hungry for them. In 2015 the ITV network screened *Flockstars*, a show which saw celebrities clad in checked shirts and Barbour accessories learning to herd sheep at a series of staged sheepdog trials. For the perhaps more serious consumer of countryside TV, *Spring Watch*, *Autumn Watch* and *Winter Watch* have grown in popularity, as has the space they occupy in the network schedule. In 2013 a BBC report identified *Countryfile* as the 'jewel in the crown' of the network's rural programming and in February 2016 figures showed that 8.7 million live viewers were tuning in, making it the most popular programme on British television at that time.[8] It has since developed a daily spin-off show and a live event held at Blenheim Palace, attracting 125,000 visitors.

When asked to explain *Countryfile's* unexpected popularity, its producer cited the somewhat mythological national malady of 'Nature Deficit Disorder'. The term was invented in 2005 by the American journalist Richard Louv and refers to a condition where too much indoor time, particularly engaged in screen-based activities, leads to a lack of connection with nature.[9] Louv argues that Nature Deficit Disorder can lead to 'diminished use of the senses, attention difficulties and higher rates of physical and emotional illnesses'.[10] He initially identified this as a particular issue for children but has since widened his diagnosis to include adults.[11] Critics have noted that there is very little evidence-based research to back up Louv's claims.[12] However, his detractors have their work cut out to counter

the appealingly nostalgic parenting scenarios that he suggests to help combat this 'condition'. These include keeping a nature journal, pressing flowers and collecting frog spawn. The mixture of anxiety and nostalgia generated by this condition has seen the National Trust, a powerful rural brand in itself, draw on the Nature Deficit Disorder concept to mobilize a family demographic with its Natural Childhood Report (2012). The report includes the Trust's manifesto for a childhood spent in the great outdoors – *50 things to do before you're 11 and ¾* – which includes activities like learning to ride a horse, canoeing down a river and playing pooh sticks.

At the same time a more prosaic yet entirely imaginary rural agricultural landscape has been created by the supermarket chain Tesco. In 2016 the store launched a new range of farm brands for fresh meat, fruit and vegetables, featuring the names of seven fictional farms which had no relation to the produce being marketed. Complaints to the Trading Standards Institute were made by the National Farmers' Union, claiming that the brands were misleading in that they appeared to indicate that the products had been farmed in the UK when many had in fact been imported from abroad.[13] Like the air fresheners, this brand uses language which draws on a set of well-established rural mythologies in order to create associations between their products and a nostalgic, comfortable, picturesque image of farming. Rosedene and Redmere Farms, nominally responsible for Tesco's fruit and vegetables, both draw on old English names for places where rushes grow, giving both imaginary locations a pleasing heritage feel. Woodside Farms, representing all things pork related, conjures an image of happy pigs rootling around under beech trees. It cannot be a coincidence that Willow Farms and Nightingale Farms, used as brand names for poultry and salads respectively, are both farms that feature on the long-running agricultural radio soap opera *The Archers* – a move which enables the brand to draw on the deeply established mythological land of Ambridge, with its close-knit community, green rolling hills and generations of farming experience. The appetite for such appealing, if entirely imaginary, images of the countryside is strong; Tesco recently attributed the popularity of their farm brands range as a significant factor in an impressive sales growth report.[14]

The circulation of these mythical images of the countryside situates the rural firmly within the realm of consumerism – through the purchasing of countryside-related products, the consumption of countryside-based programming or the enjoyment of countryside-themed experiences. These mythological relationships to the countryside have a real impact on rural places themselves, influencing public and governmental opinion on what the countryside should look like, what should and should not be allowed to exist there – and, of course, how it should smell.

NOTES

NOTES

1  'Broads Authority Agenda Item No 18 National Parks UK: Corporate Sponsorship Project Report by Chief Executive' (11 July 2014), http://www.broads-authority.gov.uk/__data/assets/pdf_file/0004/465493/National-Parks-UK-Corporate-Sponsorship-Project.pdf.

2  Ibid.

3  'Campaign for National Parks, Impact of Grant Cuts on English National Park Authorities: A briefing based on responses to Freedom of Information requests' (July 2015), http://www.cnp.org.uk/sites/default/files/uploadsfiles/Final%20national%20Stop%20the%20Cuts%20briefing%20July%202015.pdf.

4  'America's national parks eye corporate sponsorship to plug funding shortfall' (9 May 2016), http://www.independent.co.uk/news/world/americas/americas-national-parks-eye-corporate-sponsorship-to-plug-funding-shortfall-a7020786.html.

5  Roland Barthes, *Mythologies*, London: Vintage, [1957] 1999.

6  Peter Conrad, *Mythomania: Tales of Our Times, From Apple to Isis*, London and New York: Thames and Hudson, 2016.

7  http://www.nationalparks.gov.uk/students/whatisanationalpark/factsandfigures.

8  'The explosion of countryside TV helping treat our 'nature deficit disorder' (27 March 2016), https://www.theguardian.com/media/2016/mar/27/countryfile-bbc-nature-deficient-disorder?CMP=Share_AndroidApp_Email.

9  Richard Louv, *Last Child in the Woods: Saving our Children from Nature-Deficit Disorder*, London: Atlantic, 2010.

10  http://www.outdoorfoundation.org/pdf/LastChild.pdf.

11  Richard Louv, *The Nature Principle: Reconnecting with Life in a Virtual Age*, Chapel Hill, N.C.: Algonquin Books of Chapel Hill, 2012).

12  Dickinson, Elizabeth 'The Misdiagnosis: Rethinking "Nature-Deficit Disorder"', *Environmental Communication,* vol. 7, 2013, Issue 3, pp. 315–35.

13  'Tesco and other supermarkets using fake farm brands spark complaint from NFU' (19 July 2016), http://www.independent.co.uk/news/business/news/tesco-and-other-supermarkets-using-fake-farm-brands-spark-complaint-from-nfu-a7144551.html.

14  'Tesco's range of 'fake farm' foods helps to boost sales' (23 June 2016), http://www.independent.co.uk/news/business/news/tesco-results-profits-sales-fake-farms-willow-rosedene-boswell-dave-lewis-aldi-farming-a7.

# INTERVIEW
# ANDY SEWELL

**Rosemary Shirley (RS): Your project**
*Something Like a Nest* **explores how our**
**idea of the countryside intersects with**
**contemporary everyday life. Can you tell**
**me more about this?**

Andy Sewell (AS): Photography can be a
way of looking more closely at the stuff in
front of us – at the everyday. Most of the
time we don't actually see things in any
detail. For good reasons our brain is filling
in, constructing the world according to the
perceptual model we carry with us.

Allowing myself to become more
aware of these things in this moment is an

**65a**
*Untitled 08*, from
*Something Like a Nest*, 2014
Pigment print, 48 x 60 cm
© The artist

115

**65b**
*Untitled 17*, from
*Something Like a Nest*, 2014
Pigment print, 48 x 60 cm
© The artist

experience I find strange and compelling. The world can feel, paradoxically, more lucid and more mysterious. It's this quality I am trying to capture and convey in a photograph – to create, as one critic described my work, 'portraits of the act of observation'. I like to have a boundary, some sort of area staked out, within which to work. When I started *Something like a Nest* I was thinking about how the rural landscape is used imaginatively and about the contradictory uses these ideas are put to. It is thought of as a place that encourages reflection on the everyday details of life, but those details tend to be fiercely edited, removing inconsistencies that don't conform to an ideal or confirm particular positions. It seemed like a rich place to start looking at how the messy complexities and inconsistencies of the world, as we actually find it, intersect with the images we carry around with us.

**RS: Many of the photographs were taken in East Anglia. What draws you to this area? Do you think it has specific characteristics?**

AS: The most straightforward reason is that it was the closest bit of countryside to get to from where I live. I did photograph quite widely around England but, while I hope each picture has an intense sense of a specific place, I didn't want them to feel like iconic representations of a particular region. I work in a documentary style, taking straight pictures of things I find. But my intentions for the work are not primarily documentary. I wanted to steer the viewer away from reading the work as a 'survey of the English countryside' and to allow the pictures to stand for many places.

**RS: The kitchen sink – the view from the kitchen window – is a recurring subject in *Something like a Nest*. Why do you find this part of the home so interesting?**

AS: I like how rich in narrative detail they are and the sense they have of looking into a space you are separated from. This distancing is something that recurs in different ways through the work. The sinks are one of the ways the work is given structure – a kind of

leitmotiv that marks each season ... different kitchens, in different times and places, but connected in some way. In *The Heath*, my previous book, I was trying to avoid a seasonal structure, to create the feeling of a walk, but one that moved freely between different seasons ... that flowed, like our memories, in a fragmentary yet unified and apparently continuous way. Creating this feeling of journey without sticking to a seasonal structure was one of the challenges.

I experimented with a similar approach in *Something like a Nest* but I kept coming back to a more traditional form, going from one winter to another. It felt like this structure and the implication that comes with it of the creative/destructive cycle – spring birth, winter death with harvest in between – was unavoidable. It's such a central theme of the pastoral tradition that this work is in dialogue with. One of the challenges with the book was to keep to this form, but to also subvert it, to avoid rehearsing old clichés.

The image of the country kitchen is a familiar one. We might think of simple food from the surrounding fields being prepared on

time-worn wooden tables, a daily connection to the earth and the seasons. What we see in the window picture that opens *Something like a Nest* is obviously some distance from that interiors book or advertisers' idyll. The grapes flown from thousands of miles away sit in contrast to the snow outside, rustic wood is replaced by plastic. However, I also feel there is something that pulls back towards the pastoral notion of connection to fundamental things and rhythms.

I imagine the person who lives here looking out on to the slowly changing seasons as they wash up each day. Their joy in seeing the birds feed, on food bought from supermarkets. The icy blue of the washing-up bowl links tonally with the snow outside and bridges, in a strange way, the gap between interior and exterior … the muted, organic colours we expect, disrupted by the backlit plastic bottle of washing-up liquid, lurid, jewel-like … kind of beautiful and jarring. It's these tensions that I hope to weave through the work, pulling with and against established symbolism and iconic imagery.

RS: I find the image of the new housing estate where one of the houses is called 'Jumbolair' really fascinating. Vernacular building techniques like dry-stone walls and cottage-style architecture have been appropriated to create these large new luxury homes, and central to this we see the England flag. Could you tell me more about why you chose to include this image in the collection?

AS: Those contrasts are I think one of the things that gives energy to the picture – building techniques that were once a practical solution to a problem, which have become part of a mannered rural aesthetic. I see in the picture a desire for tradition (one of the central pastoral impulses) that sits at odds with the theme park feel. And then there's the house name ….

The picture is within the spring section of the book. I like the way the new leaves on the trees and the freshness of the buildings sit with each other and with the other pictures figuring birth/rebirth in this part of the work.

RS: Harvest festival is a tradition that connects very obviously with the rural, but today we are more and more alienated from food production. I really like your image of a contemporary harvest festival. Can you tell me more about it?

AS: This picture contains many of the tensions that exist in the work as a whole. To find these plastic-wrapped supermarket commodities representing the harvest feels kind of dispiriting … especially when set against the idea of the countryside as a place of connection to the land. These items could be seen as symbols of disconnection from place, from the season, and [of] the pervasiveness of the corporate and the generic. But it is also sign of a community coming together in order to mark a change in the seasons and perhaps think about the inequalities of society – the food goes to charity. There is something in the way the light falls, the radiance of the plastic bags and the altar cloth, and the way materials from different centuries comfortably sit together, which I find strangely uplifting.

**Georgina Barney** spent eight moths in 2007 living and working on fourteen farms across Great Britain, from North West Scotland to the southern tip of Cornwall. This journey, *GB Farming*, published in 2017, has been a foundation to ten years' subsequent work engaged with the rurally isolated subject of farming and the metropolitan discourse of contemporary art. Barney studied Fine Art at The Ruskin School of Fine Art, University of Oxford (BFA), and undertook an AHRC-funded project, *Curating the Farm*, at Gray's School of Art, Aberdeen. Barney now lives in Nottingham, where she is a resident artist at Primary.

**Dr Nicola Bishop** is a Senior Lecturer in English Literature, Film and Television at Manchester Metropolitan University. She has previously written about rambling fiction in the early twentieth century, class in the works of Agatha Christie, and the representations of office workers in modernist fiction. Nicola is also interested in the light docu-tainment programmes that feature the 'countryside' or rural landscapes and new nature writing. In her spare time, Nicola likes to participate in 'active research' by reading, hiking and running in the Lake District with her dog, Molly.

**Dr Jeremy Burchardt** is Associate Professor in Rural History at the University of Reading. His research focuses on the social and cultural history of the countryside in the nineteenth and twentieth centuries, especially leisure and rural social relations, and attitudes to the countryside. He is the author of *The Allotment Movement in England, 1793–1873* (Boydell & Brewer, 2002) and *Paradise Lost: Rural Idyll and Social Change* (IB Tauris, 2002), and of various articles, and has edited books, most recently *Transforming the Countryside: The Electrification of Rural Britain* (Routledge, 2016; with Paul Brassley and Karen Sayer).

**Alice Carey** is a curator and arts administrator whose particular interest in farms and farming relates to a wider practice around interdisciplinary research and collaboration. She is currently employed as an Arts Advisor at the Wellcome Trust, having previously worked with organizations including the Natural History Museum, Bobby Baker's Daily Life Ltd and the Wellcome Collection. Her independent research into 'the idea of the farm' grew out of life-long fascination, a curatorial collaboration with artist Georgina Barney, and her Research Masters at the London Consortium. Alice lives in London and grew up on a farm in Norfolk

**Rebecca Chesney** is a visual artist whose work is concerned with the relationship between humans and nature and how we perceive, romanticize and translate the landscape. Her projects take the form of installations, interventions, drawings, maps and walks. She has been commissioned by Yorkshire Sculpture Park, the Bronte Parsonage Museum, Grizedale Arts and Landlife, and was awarded a Gasworks International Fellowship in 2013. She has been an invited artist in residence at the Nirox Foundation in South Africa, Peak in the Brecon Beacons National Park and Montalvo in California, USA. Her work has been widely exhibited in UK as well as in Japan, Germany, India, Spain, Ireland and Italy. She is based in Preston, UK.

**Verity Elson** is a curator whose recent exhibitions at Compton Verney include *The Hart Silversmiths: A Living Tradition, Martin Parr: The Non-Conformists* and *Picasso on Paper. Creating the Countryside* was developed in response to a lifetime spent living and working in rural communities and an interest in social themes in British art developed during her MA at the University of St Andrews. The exhibition has been shaped by her experience of and passion for programming contemporary projects in historic settings.

**Anna Fox** is Professor of Photography at University for the Creative Arts in Farnham. She has been working as a photographer since 1983 and in 2010 was shortlisted for the prestigious Deutsche Borse Prize. Fox has exhibited and published her work internationally and her last two books, *Resort 1* and *2*, are published by Schilt in Amsterdam. She was the main organizer for *Fast Forward: Women in Photography* conference at Tate Modern in 2015 and her work has been selected as part of the major British Council exhibition *Work, Rest and Play: British Photography since the 1960s.*

**Dr Nick Groom**, Professor in English at the University of Exeter, is author of *The Seasons: A Celebration of the English Year*, shortlisted for the Katharine Briggs Folklore Award and runner-up for Countryfile Book of the Year 2014. He has also published widely on national identity (*The Union Jack*, 2006) and the Gothic (*The Gothic*, 2012), as well as on many other aspects of culture, including forgery, maritime politics, vampires and climate change. He has a small flock of Black Welsh Mountain sheep.

**Sigrid Holmwood** is a Swedish/British artist based in London. She has a BFA from the Ruskin School of Art, Oxford, and an MA in Painting from the Royal College of Art. She has exhibited nationally and internationally, at venues including Annely Juda Fine Art (2008, 2012); the Saatchi Gallery, London (2010, 2016); the Gallery of South Australia, Adelaide (2011); and the State Hermitage Museum, St Petersburg (2009). She has worked on solo projects in collaboration with Vitamin Creative Space, Beijing (2011); Halland's Art Museum, Sweden (2012–13) and Joya: arte + ecología, Spain (2013–, ongoing).

**Hilary Jack** works across media in research-based projects often involving the collecting and re-purposing of found objects in site-referential artworks, sculptural installations and public interventions. Her work has an activist element, highlighting the concept of built-in obsolescence while commenting on the impact of human activities on our planet. Recent work in particular acknowledges contemporary anxieties over geopolitics and environmental change. She has exhibited across the UK and internationally and was awarded the 2016 Spinningfields Art Commission by Allied London.

**Delaine Le Bas** is an English Romani Gypsy. She studied at St Martin's School of Art, London. Her practice includes installations, drawing, performance, film, photography and sculpture. Her work deals with issues of exclusion, identity, stereotypes, untold histories, misrepresentation, gender and being the 'other'. She has exhibited internationally, at venues including the Venice Biennale (2007), the Prague Biennale (2005, 2007), the Gwangju Biennale (2012), the Zacheta National Gallery of Art (2013), MWW Wroclaw Contemporary Art Museum (2014), The Third Edition Of The Project Biennial Of Contemporary Art D-0 Ark Underground Bosnia and Herzegovina (2015), Off Biennale Budapest (2015), and Goteborg International Biennial For Contemporary Art Extended (2015).

**Ingrid Pollard** comes from a community arts background with training in film and photography. Narrative is an important aspect of her work as is the materiality of photographic process. Her practice concerns questions of social constructs such as Britishness and racial difference. While investigating race, ethnicity and public spaces she has developed a body of work juxtaposing landscape and portraiture, which provide a context for issues of migration, family and home. She is an Honorary Fellow of the Royal Photographic Society and her work is held in collections in the Victoria and Albert Museum, Tate Britain, and Arts Council, England.

**Andy Sewell's** work is in collections including the Victoria and Albert Museum, Museum of London, Foam, National Media Museum, Eric Franck Collection, and The Hyman Collection. He is a winner of the International Photobook Award and included in Martin Parr's *The Photobook: A History* vol. III. His *The Heath* was described by *The Guardian* as 'a book of suggestion, a landscape of the imagination as well as a record of a real and familiar place. A classic of understated observation'. *The Telegraph* wrote of *Something Like a Nest*: 'A series of intensely concentrated impressions that reward and indeed encourage a slow, measured drinking-in'.

**Dr Rosemary Shirley** is a Senior Lecturer in Art Theory and Practice at Manchester School of Art, Manchester Metropolitan University. Her research centres on everyday life and visual cultures, with a particular emphasis on contemporary rural contexts. She is interested in how the English landscape might be explored through discourses of modernity. This has led her to write about topics as diverse as litter, motorways, folk customs, scrapbooks and the Women's Institute. She is the author of *Rural Modernity, Everyday Life and Visual Culture* (Routledge, 2015).

**67**
**ANNA FOX**
*Back to the Village: Hampshire*
*Village Pram Race*, 2004
Matt light jet print archival, 74 x 74 cm
© The artist, courtesy of The Hyman
Collection, London